IMAGES
of America

FIFE

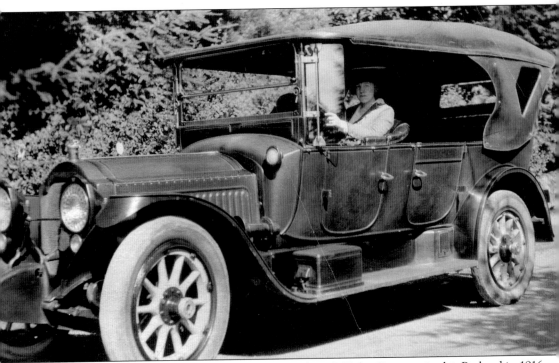

Hop on board and enjoy the excursion through Fife with Helen Peterson in this Packard in 1916. This journey will take the reader to a budding valley community during the time period of the 1890s into the 1960s. Many of the residents are fairly recent arrivals from European countries, and there are also a number of families who made the trip from Japan. Enjoy this tour through Fife of yesteryear. (Courtesy of Brian C. Payne.)

IMAGES
of America

FIFE

Susan Kaelin

ARCADIA
PUBLISHING

Published by Arcadia Publishing
Charleston, South Carolina

Printed in the United States of America

Library of Congress Control Number: 2011929768

For all general information, please contact Arcadia Publishing:
Telephone 843-853-2070
Fax 843-853-0044
E-mail sales@arcadiapublishing.com
For customer service and orders:
Toll-Free 1-888-313-2665

Visit us on the Internet at www.arcadiapublishing.com

This Images of America book about Fife is dedicated to my parents, grandparents, and all of the families who contributed to creating the Fife community.

CONTENTS

ACKNOWLEDGMENTS

There are so many people who have made contributions to this telling of the story of Fife that the space provided here is insufficient to recognize all of them individually. This book would not have been possible were it not for all of the wonderful photographs that were shared by these family members. The photograph credits will give an indication as to how many people were involved.

Special recognition goes to Dr. Ron Magden, a retired history professor. I am constantly learning during our conversations. Dr. Magden's book *Furusato: Tacoma-Pierce County Japanese, 1888–1977* was completed with contributions coming through the Furusato Book Committee and is a wonderful resource for those wishing to know more about the Japanese settlers who came to Pierce County.

Special appreciation is also extended to Leslie Gould for her preliminary study of Fife's history over 30 years ago and to Pat Reed. A native Californian, Fife Historical Society board member, and Fife School District employee, Pat shares my interest in collecting historical photographs and has come to know, preserve, and communicate Fife's history—particularly the history of the Fife schools. John Ratko, a former Fife School District administrator, was my US history teacher in high school. Because of his interest in the history of Fife, he worked to gather pertinent documents years ago, and it might be said that he helped to set the stage for the work that evolved. Bev Albert Walsh received a few calls from me regarding questions I had about Fife's history. Donna Libert provided helpful guidance as the Arcadia Publishing representative.

Finally, appreciation is extended to the Fife Historical Society. Be sure to check out the Fife History Museum. Donations of photographs, artifacts, and stories that help to tell the story of Fife are always appreciated.

This is the first book ever published about Fife; the intent was to have it be as accurate as possible given the text space allowed. There are still more photographs to be uncovered, questions to be answered, and stories to be told. Should you have such contributions, please feel free to report your findings and/or any missing names to fifehistory@comcast.net.

INTRODUCTION

In the years preceding and during European exploration of North America, the Puyallup Indians were spread across the region from Mount Rainier to the shores of Puget Sound. The tribe's villages typically were in one of four cultural categories—saltwater, river, prairie, and inland. Cedar was used for their homes, tools, canoes, and clothing; salmon, shellfish, wild game, roots, and berries would have been a part of the typical menu.

The Puyallup were one of the tribes for which the Medicine Creek Treaty was established and ratified by Congress in 1855. A portion of the treaty was to identify a designated reservation for each of the tribes, and two years later the amount of land set aside for the Puyallup totaled over 18,000 acres. The Puyallup reservation would be adjacent to the Puyallup River and Commencement Bay and would include what is known today as Fife, Washington.

In 1883, the completion of the Northern Pacific Railroad with Tacoma as the terminus would open the door to many who considered moving west. There were 7,000 people in Tacoma in 1885, and by 1890, there were 36,000. Those seeking a new beginning saw the journey to the greater Tacoma area as an opportunity for a brighter future.

Another change would come to the members of the Puyallup tribe in 1887, when the reservation would be divided among the individual tribal members. This was the result of the Dawes Severalty Act, named for the Massachusetts senator Henry Dawes, who headed the US Senate's Committee on Indian Affairs. By dividing the reservations in this manner, Congress hoped it could force the Native Americans to adopt the farming methods of the early pioneers. A few members adopted such practices, but this change primarily opened the door for developers and pioneers, and that is where the story of Fife begins.

One

EARLY FIFE FAMILIES

Within this first chapter, the reader will be introduced to some of Fife's earliest settlers. A large proportion of these pioneers were from Switzerland, Italy, and Japan. Others had roots in Austria, Sweden, Finland, Poland, England, or Germany.

Today, Switzerland may be viewed as a prosperous country, but in the late 1800s, some residents were hearing of streets paved with gold in this new land. Young men and women chose to explore a new continent offering hope of new beginnings and plenty of space. Seeking farmland for dairies, the Swiss were among the first to procure acreage on the Puyallup reservation. Until the farms were firmly established, the land was leased from individual Puyallup tribe members, who were the designated owners.

While a number of Italians left Italy for other parts in Europe, many hardy souls made the long crossing of the Atlantic. Half of these folks came to the United States, while others explored opportunities in Argentina and Brazil. Many of those who made the trip to Fife came together to establish and maintain a successful cooperative farm known as Colonial Gardens. This allowed them to pool their resources while creating a future for their families.

In the late 19th century, Japanese adventurers began to arrive on the shores of the United States. One of the reasons for their departure from Japan was because of a revised tax system. Farmers had previously been able to pay with agricultural goods, but the new system required currency, and many were unable to make these payments. Additionally after the Russo-Japanese War (1904–1905), the Japanese were encouraged to seek opportunities abroad, as the returning soldiers were unable to find employment. Furthermore, only the eldest son could inherit his father's property. The younger sons could venture out on their own, or they could marry into a family of only daughters and hope to acquire land as part of the union. Many of them began their American journeys in the larger cities or in logging camps—until they had an opportunity to work the land.

In 1907, an agreement was made between Japan and the United States regarding Japanese immigration; this Gentlemen's Agreement provided that Japan would not issue passports to Japanese citizens wishing to work in the continental United States. Wives, children, and parents of those who had arrived in the United States would be allowed to join their family members already here. In return, there was to be no discrimination toward Japanese students; this had been a more significant problem for those Japanese families who had settled in California. Unfortunately, there were incidents of discrimination or of discriminatory remarks made in other locations—including Fife, where a white citizen had proposed to the Fife School Board that Japanese students should attend their own schools. Such a proposal found little support in Fife.

The year 1907 also marked the formation of the United States Immigration Commission, a special Congressional committee chaired by Sen. William Dillingham of Vermont. Its findings provided the impetus for legislation impacting immigration in the 1920s. Most significant was the Immigration Act of 1924, which imposed restrictive quotas for immigration from Southern and Eastern Europe and barred any immigration from Asian countries

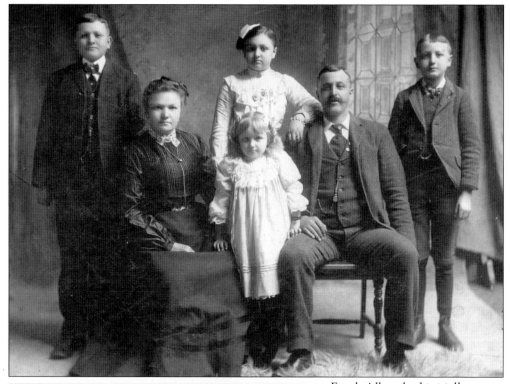

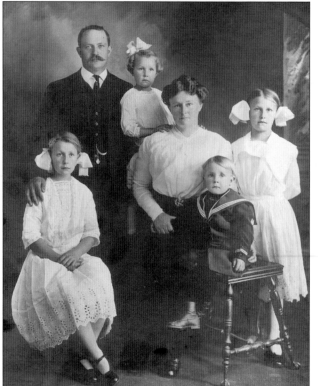

Frank Albert had initially emigrated from Switzerland to Minnesota, where he lived for a few years before moving to Fife in 1892. This c. 1904 photograph of the family includes, from left to right, Frank Jr., Martha, Katherine, Rose, Frank Sr., and Max. Frank Albert Road was named for this early Fife settler. (Courtesy of the Frank Albert family.)

The Alexander Fox family settled near the intersection of Valley Avenue and Seventieth Street. Alex and his wife, Katherine, were also from Switzerland, where the German spelling of the name *Fox* is *Fuchs*. Some immigrants kept the German name. The Foxes' children, from eldest to youngest, include Rose, Mary, Louise, and Alex. (Courtesy of Georgine Salzmann.)

In front of their home around 1925 on Goldau Road (Alexander Avenue) are, from left to right, Bertha, Leo, Edward, Mary, Victor and Martin Kaelin. Marti Road, now known as Twelfth Street, was named for Martin, who emigrated from Einsiedeln, Switzerland, in 1887 with his first stop in Louisville. Frank Albert and Martin Kaelin were two of the nine to incorporate the Tacoma Swiss Men's Society. The author is Victor's daughter. (Courtesy of the Victor Kaelin family.)

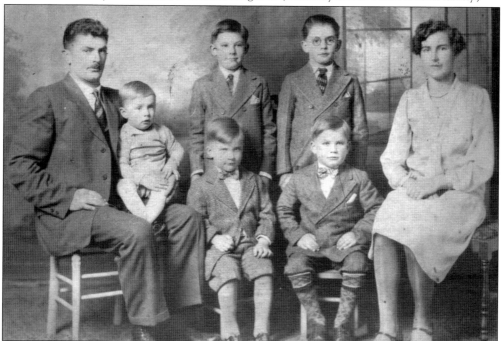

Meinrad "Mike" and Anna Bisig, along with their two eldest boys, arrived from the canton of Schwyz in 1921. Young Albert is pictured on his father's lap in 1928; from left to right are (seated) Johnny and Walt and (standing) Fred and Mike. The Bisig family initially rented a farm, but in 1939 they moved to the Meinrad Gyr home. It was at this time that Meinrad went to work in the bottling department of Darigold in Tacoma. (Courtesy of the Bisig family.)

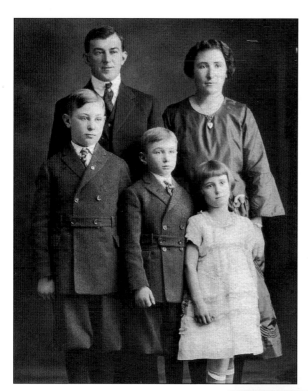

Angelo Bevegni and Jennie Boitano Bevegni were both from Genoa, Italy. Angelo was one of the leaders at the Colonial Gardens. Pictured with Angelo and Jennie around 1922 are their children Fred, Robert, and Emma. Jennie continued to maintain their lovely brick home and yard for a number of years after Angelo's death. (Courtesy of the Bevegni family.)

Pictured here are Joseph and Lilly Garre and their son, Edward. Nearly all of the Italians in the community came from Genoa, and young Edward was able to visit his parents' homeland in 1930 at the age of nine. The Garre family was one of a number of Italian families who lived on Goldau Road, which was near the heart of the Colonial Gardens. (Courtesy of the Edward Garre family.)

The Reghitto family also lived on Goldau Road. In this c. 1921 photograph are, from left to right, (seated) Rosie, Della, their mother, Virginia, and Inez; (standing) Ann Reghitto and her father, Augustino Reghitto. It is believed that the other two people are Virginia's brother-in-law and her sister. (Courtesy of the Patricia Durocher family.)

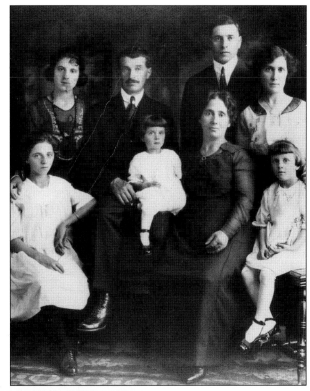

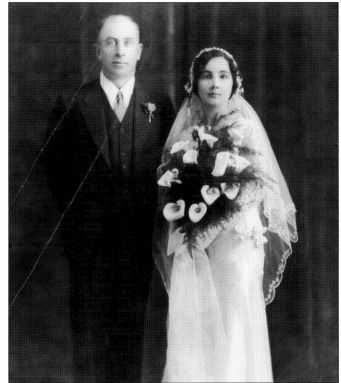

The eldest brother of Jenny Boitano Bevegni was Angelo "Andy" Boitano. In 1931, Andy married Victoria Dacca, the sister of Louis Dacca, one of Fife's first city councilmen and a lifelong farmer. Andy and Jenny were born in Italy. Andy was unable to travel to America when his sister and mother did, as he had pinkeye. He joined them the next year, when he was 14. (Courtesy of the Andy Boitano family.)

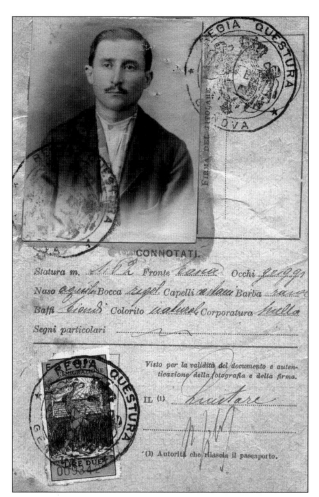

This is one side of the passport of Julio Canale, who came to Fife in 1921. The Canale home was located on the Pacific Highway, near Goldau Road. (Courtesy of Dorothy Canale Johnson Amrein.)

Still situated on Highway 99 west of Alexander Avenue is what was once the home of Julio and Josephine Canale. Their only child, Dorothy (Johnson) Amrein, has lived in the Fife area her entire life, and her three sons are also Fife High School graduates. (Courtesy of Dorothy Canale Johnson Amrein.)

Pictured here around 1921 is the Sahei "Sam" and Iwaye Uchida family, who lived on North Levee Road. Their four eldest children are, from left to right, Chilyoko, Isamu, Kazue, and Kiyoko. (Courtesy of the Yotsuuye family.)

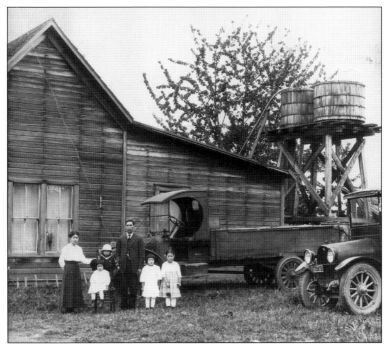

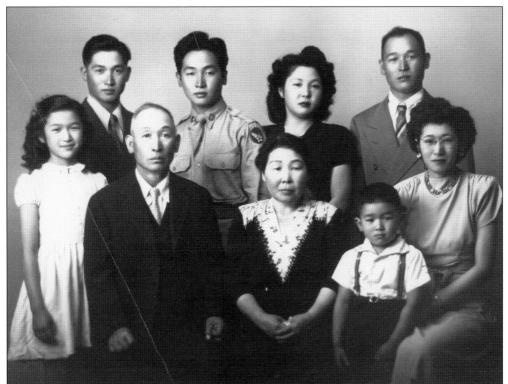

Pictured here is the Hiroaki Yotsuuye family. From left to right are (first row) Elsie, Hiroaki, Sadao, Tom, and Kazue (Uchida); (second row) Akinobu, Tadao, Mary, and Toju (Tom Sr.). (Courtesy of the Yotsuuye family.)

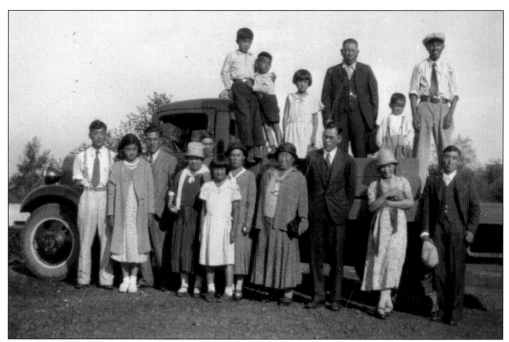

These are the members of the Chojiro and Hana Kawabata family dressed and ready for a trip to Vancouver, BC, around 1934. (Courtesy of the Kawabata/Kawasaki family.)

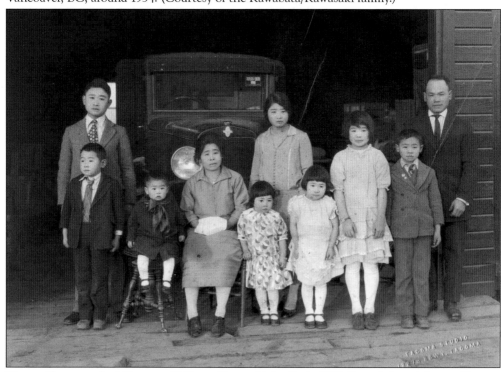

Pictured here are the Hikozo and Rikuye Kawasaki family in 1931. From left to right are George, Don, Hachi, Rikuye, Maki, Kuni, Kash, Mitsie, Leo, and Hikozo. (Courtesy of the Kawabata/Kawasaki family.)

The Kurimoto family was involved in a number of community ventures—including the development of the Japanese Language School in Fife. Seated in this 1934 photograph are Hiroshi and Itono Kurimoto. Their children, from left to right, are Kiyoshi, Ayako, Toshiko, Takashi, and Atsushi. (Courtesy of the Takashi Kurimoto family.)

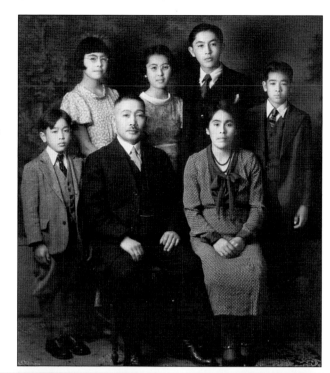

The Heisuke Ohashi family arrived in the United States in 1906. The eldest daughter, Ayako (far left), would be one of the representatives of the Puyallup Valley when the Japanese American Citizens League (JACL) was formed in 1930. (Courtesy of the Ayako Ohashi Okubo family.)

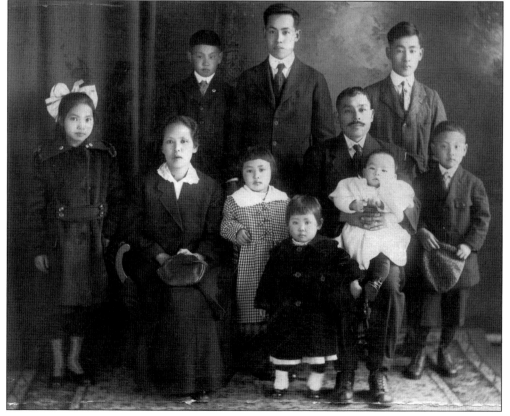

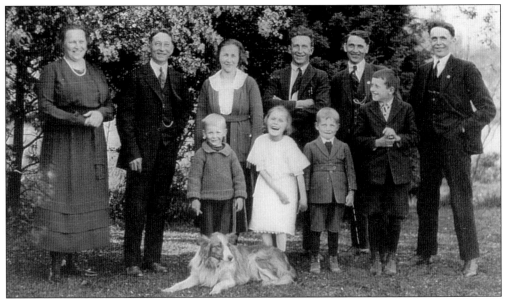

The Bornander family lived adjacent to what would become Highway 99, also known as the Pacific Highway. In fact, their home was one of many that would be moved back from what became a major thoroughfare. (Courtesy of the Ernest Bornander family.)

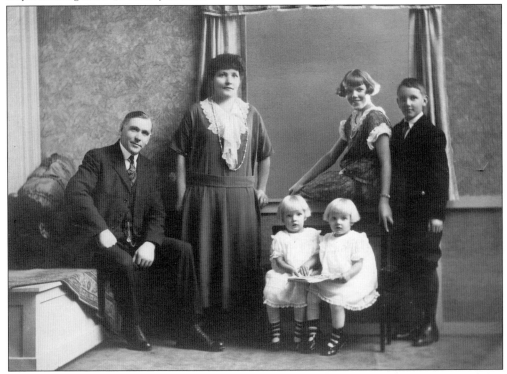

Otto Hanson was a cabinetmaker and rode the nearby interurban to work. Here, he is with his wife, Signe, and their children Thelma, Ivar (the eldest), and twins Mildred (left) and Marion. They came to Fife from Sweden around 1915 by way of Alaska. They lived near the Bornanders and would also have to move their house back for the highway. (Courtesy of the Merritt family.)

August Olson initially lived in Ruston and worked at a mill during the week and on his farm property on weekends. He built the barn first and then a cabin for his wife, Albertina, and children—John, Anna, and the baby, Ester, who are pictured around 1897. Arvid, who would take over the farm, was not yet born. (Courtesy of Arvid and Leah Olson family.)

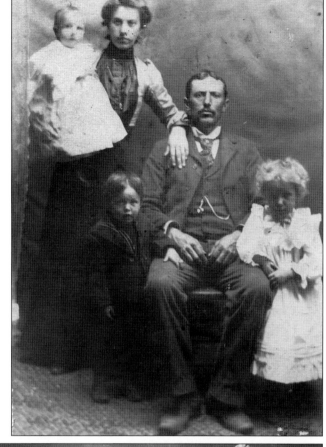

Gustaf Peterson came to America in 1894. Pictured here around 1906 are, from left to right, Eldon, Gustaf, Clarence, Agnes, Anna, Edward, and Helen, who was one of the first two Fife High School graduates in 1916. The Petersons' son Winston would join the family in 1914. (Courtesy of Brian C. Payne.)

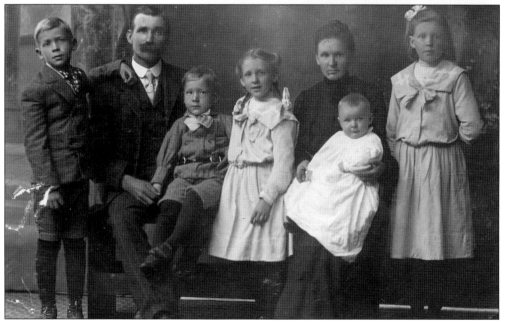

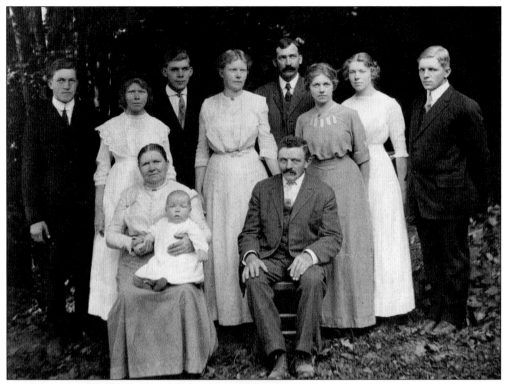

Henry Benthien, whose name is probably best known as one of the five founders of the Puyallup Fair, lived out his life as a nursery owner in Fife. In this c. 1912 photograph, Henry is seated with his wife, Maria, and their grandson Clarence Mueller. From left to right are Benthien family members William, Henrietta, Hans, Bertha Mueller, William Mueller, Dora, Emma, and Peter Henry. (Courtesy of Marion Iversen Butler.)

Julius and Mary Gius met in Alaska, married, and, while there, had three children—John (left), Esther, and Julius—pictured here around 1916. Cyril would arrive in Washington in 1920. They would be one of at least four families surnamed Gius living in Fife during the 1920s; all came from the same area of Italy, as did the Erspamer families. This region was part of Austria prior to World War I. (Courtesy of the Julius and Mary Gius family.)

Two

GARDENVILLE

Gardenville was probably the perfect name for a community that appreciated and took advantage of its luxuriant, alluvial soil. Flowers became plentiful, as did various vegetables, berries, and fruit trees. Gardenville was also the moniker for the interurban stop nearest the center of town, and it was the name used to designate the community for the 1930 federal census.

One of the more interesting individuals who may have contributed to the naming of Gardenville was George Lawler. George was born in 1861 and lost his father just three years later as the result of a Civil War battle. George's early years were spent in the Midwest, where he worked as a clerk, telegraph operator, railroad agent, bookkeeper, and finally manager of some lumberyards.

In 1888, George came to Tacoma and secured a position as a bookkeeper for the Pacific Mill Company, which was on the waterfront near the smelter. When this mill closed, he went to Mason County and had a variety of responsibilities for a logging company there. In 1893, George decided to borrow funds from friends and family and enter into a partnership with Dr. Fred Miller in order to purchase land on the Puyallup Indian reservation. He also entered into the real estate business about this time.

Being one with an assortment of interests, George began raising a variety of bulbs—including daffodils. By 1920, he had one acre in bulbs, from which he sold nearly 250,000 cut flowers. Ultimately, he was the first to ship bulbs from the West Coast to Chicago; he was growing more flowers than what Tacoma florists and vendors could handle locally.

In 1932, George suggested having a "Bulb Sunday" when people could visit the fields and receive free flowers. The second Bulb Sunday was held in 1933, and the roads were so jammed with cars that the event was discontinued. Replacing this event was the Daffodil Parade, as suggested by a Tacoma photographer in 1934.

The Lawlers would eventually own nearly 400 acres of land in Roy, which was purchased by the United States government in 1941 for the expansion of Fort Lewis.

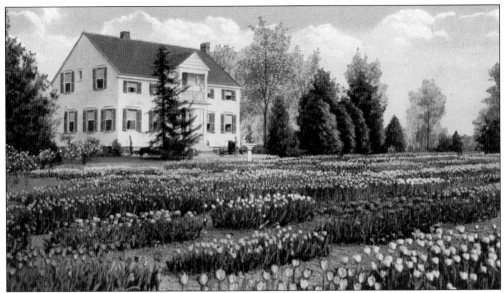

In 1910, George Lawler purchased another piece of property and built a beautifully landscaped home not far from where his sister lived. The land was close to Blue Road, which was named for his sister's married name. This Leland Lund postcard depicts the Lawler home and grounds; it is entitled "George Lawler's tulip garden, showing 20,000 tulips in bloom, Gardenville, Tacoma, Wash." (Courtesy of the author's collection.)

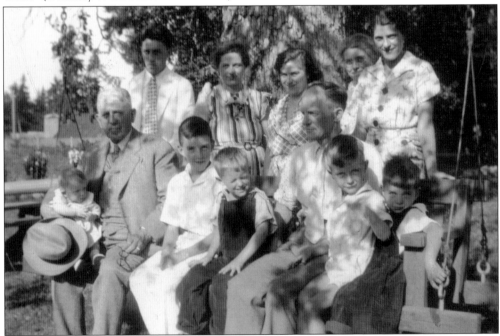

This photograph was taken in August 1936 at the home of George Ward Lawler. Those seated from left to right include George Lawler, who is holding the baby and the hat; John Ward Lawler, George Ward's son; an unidentified cousin; George Ward Lawler, George's son; Donald Lawler, George Ward's son; and an unidentified cousin. The people standing are unidentified. (Courtesy of James W. Lawler.)

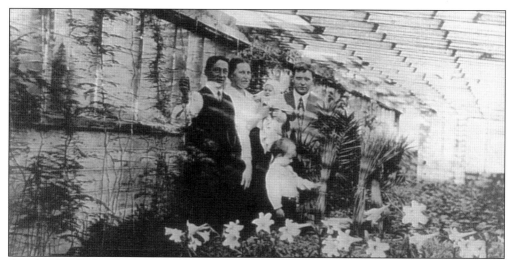

Another family that grew flowers was that of Ernest Bornander. Arriving in Pierce County in 1903 from Sweden, Bornander went to work for George Lawler, and he learned to speak German (but not English). Bornander's wife, Margit, had come to America to work for a family in Providence, Rhode Island. Here, from left to right, Bornander and Margit are in their greenhouse with Dorothy, Anders, and Margit's brother. (Courtesy of the Ernest Bornander family.)

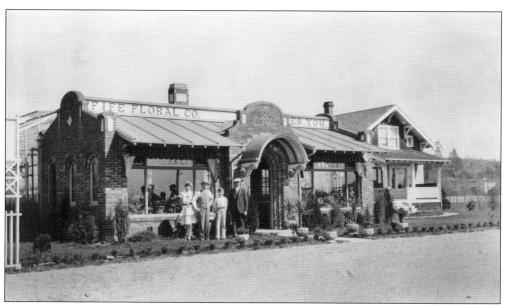

Ernest Bornander (second from left) purchased 10 acres from Henry Sicade in about 1910. Bornander cleared the land and began the Fife Floral Company. The nearby interurban would take the flowers to the wholesale market in town, while flowers and bedding plants were available in Bornander's shop. Also pictured are Carl Johnson (far right) and his two children. The Johnson family was visiting from Los Angeles. (Courtesy of the Carl G. Johnson family.)

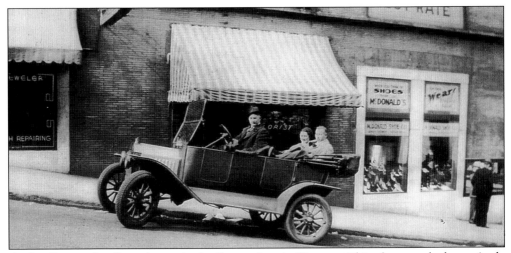

Anders Bornander, Ernest's son, had a flower shop in Tacoma. This photograph shows Andy Erickson (left) and the Andersons in front of Anders Bornander's Tacoma store in Erickson's 1912 Ford. (Courtesy of the Ernest Bornander family.)

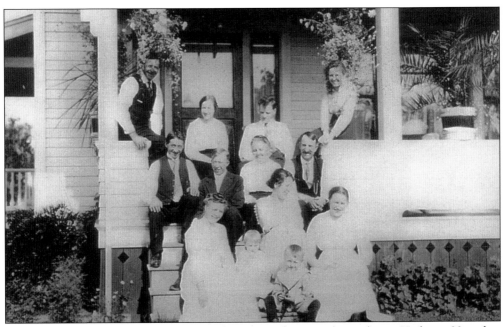

The home, business, and greenhouses of the Bornanders were located near Highway 99 and to the east of the Poodle Dog restaurant. Pictured here are family members gathered on the porch of their home graced with flowers. (Courtesy of the Ernest Bornander family.)

The Arthur Seamons family would begin what would in the mid-1930s become the Gardenville Greenhouses. Arthur arrived in the United States from England around 1894. He is seated around 1914 with his wife, Lena Rose, and their daughter Alice. Standing are their son Joseph, (probably) Rose's mother, and daughter Bertha. (Courtesy of Margaret Hart Rockett.)

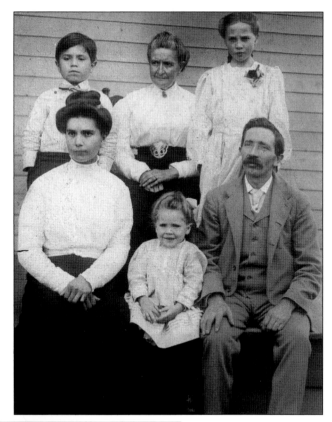

Gardenville Greenhouses were purchased by the Mizukami family in 1937. During the time the family was interned (1942–1945), the property was in the possession of three different owners. The Mizukami family purchased the land again following the war. They had a little over 20 acres, some of which was rented by Colonial Gardens. (Courtesy of the Fife Lions Club.)

Pictured here are Frank Mizukami, ? Iwata, Isami Mizukami, and Naonobu Mizukami in 1958. Frank was a partner in the family's wholesale business, which sold to retailers such as Andre's Market, Poole's in Tacoma, and area grocery stores. (Courtesy of Frank Mizukami.)

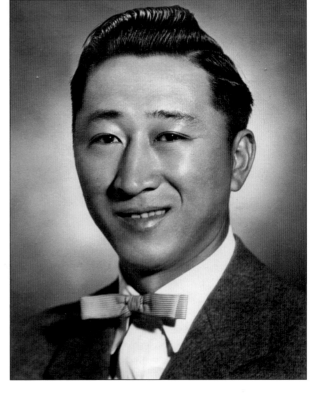

Robert "Bob" Mizukami, like his brother, Frank, was active in the Fife community. In 1956, Bob was president of the Fife Lions Club. In 1957, he would become one of the members of the first Fife City Council; he ultimately became the town's second mayor. (Courtesy of the Fife Lions Club.)

Miethke's Nursery was yet another notable greenhouse that appreciated the volcanic soil found in the area. Customers came from Seattle, Tacoma, and surrounding communities. Many would have the Miethke family create the flower arrangements for their weddings and funerals. (Courtesy of the Henry Oscar Miethke family.)

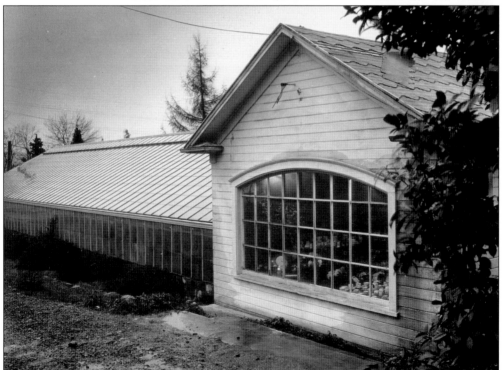

The Miethke Nursery was located at the base of the Milton Hill. F. Robert, Elizabeth, and their son, Henry, arrived in the area around 1899 from Germany, by way of Indiana, where Henry was born. The former flower shop is currently occupied by Dr. Garard Gustafson, an optometrist, a Fife High School graduate and son of Dr. Lloyd Gustafson. (Courtesy of the Henry Oscar Miethke family.)

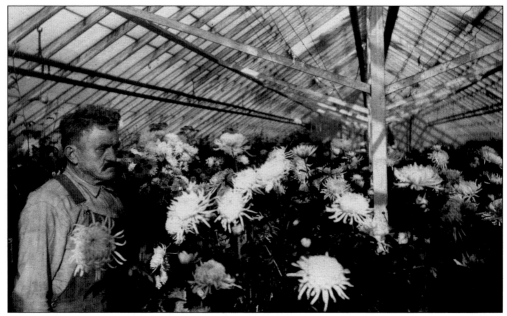

Henry Benthien, who was born in Germany in 1859, began his American journey in the Midwest. When he came to Pierce County, he briefly went to work for George Ryan in Sumner before leasing 15 acres and cultivating a vegetable garden. In 1902, Benthien purchased 70 acres in Gardenville, and sometime between 1906 and 1911, he constructed a large home that remains in the Benthien Loop area. (Courtesy of Marion Iversen Butler.)

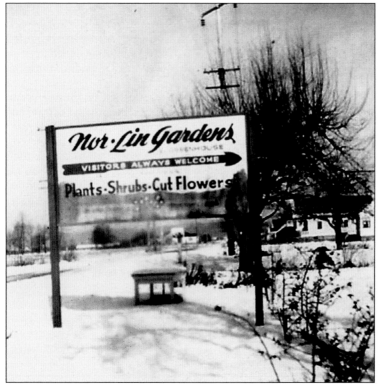

Olga Cronquist lived in what was originally the Camillo Erspamer home on Fifty-fourth Avenue near today's Columbia Junior High School. From 1950 to 1955, she had a nursery business named for her children, Norman and Linda. She had previously called it Twin Cedars Nursery, but then the trees she had named it after were taken down. (Courtesy of the Olga Cronquist family.)

Three

FIFE FARMS

Fife is a valley town that looks up at the majestic Mount Rainier, a mountain that the Japanese settlers referred to as Mount Fuji. The town is bordered by the Puyallup River, and the Wapato and Hylebos Creeks wind their way through the landscape to Commencement Bay. Tacoma sits on the hill to the west, while Milton and Edgewood are on the hill to the east.

Once property became available for lease or purchase, eager immigrants were ready to prepare the land and to establish their farms. Henry Sicade, a prominent Puyallup tribal leader during the 1890s and the early part of the 20th century, would often serve as the negotiator for leasing or purchasing Puyallup Reservation acreage from individual landowners.

Preparing the land entailed the clearing of trees, dynamiting of stumps, removal of rocks—and for the Swiss, the building of fences for containment of their herds of dairy cows. Had the settlers needed to perform extensive excavation, they might have discovered two layers of buried trees—a vertical layer covered by a horizontal layer—indicative of the Mount Rainier mudflows from an earlier time.

John McAleer, originally from Ireland, negotiated a lease for 40 acres of land on the reservation and moved his dairy farm from the Sixth Avenue district in Tacoma. He continued to lease and purchase land until he acquired a total of 400 acres in Fife. As his farm expanded, McAleer hired Swiss, Italian, Japanese, and German men to milk his cows and to work in his vegetable gardens; laboring for other farmers was how immigrants often procured sufficient funds to acquire their own land. In 1907, McAleer sold his cows but continued to lease his land. He began to focus his energies on the real estate business, which he pursued until 1917. That year, McAleer got married and constructed a large home that was located on Fifty-fourth Avenue, near the creek and across the road from the Catholic church parking lot.

For the first 60 years or so, Fife was a melting pot of farms. The Swiss were proud dairy farmers. The Italians cultivated the well-remembered and successful Colonial Gardens, which was incorporated in 1912. And the Japanese nurtured beautiful gardens of vegetables and berries, and some chose to raise and market hogs. By 1912, there were 74 Japanese families leasing land, making Fife one of the largest Japanese agricultural communities in western Washington.

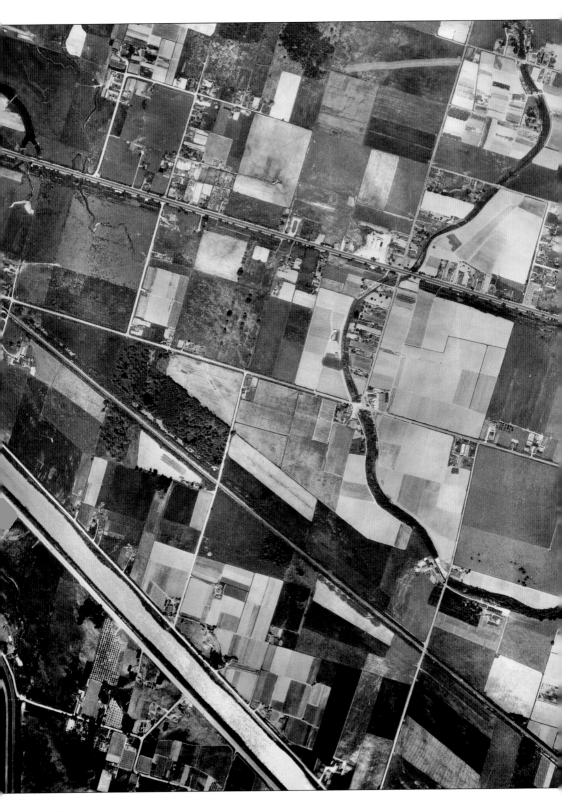

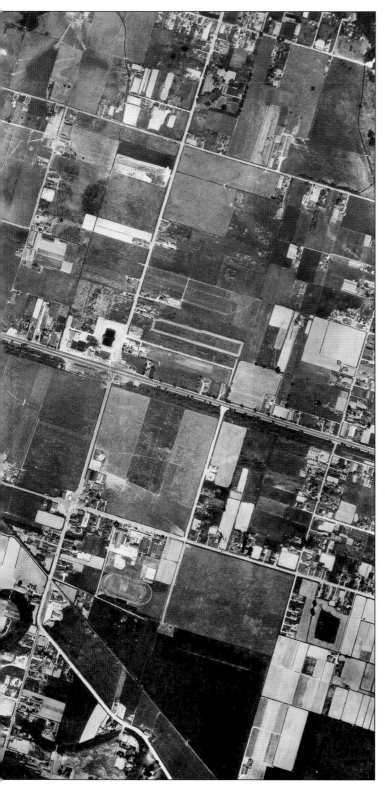

In 1949, this photograph of Fife was taken as part of the preliminary study for the development of Interstate 5. Note the meandering path of Wapato Creek. The Puyallup River is in the lower left quadrant, and the school's track is visible in the lower right quadrant. Visible at the main intersection of Highway 99 and Fifty-fourth Avenue is the curved roof of the Century Ballroom, which is just north of the Poodle Dog restaurant. Most notable is how extensive the farmland is—forming a patchwork of beautiful textures. (Courtesy of the Washington State Department of Transportation, Aerial Photography Unit.)

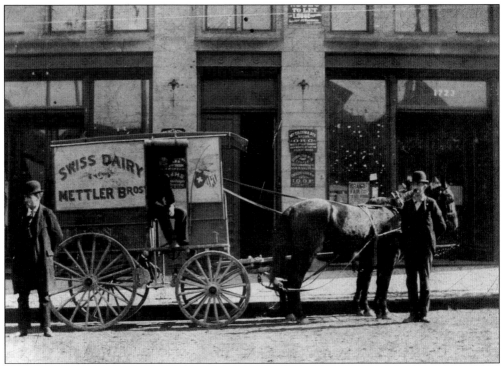

In the fall of 1890, Carl Mettler leased 40 acres; in time, he would lease 300 acres. The Mettler Brothers' Swiss Dairy was one of the first to be established in Fife and the first with Holstein cattle. Carl, Simon, and Louis had come from Goldau, Switzerland, and Goldau was the name given to the road that ran past their property. Carl Mettler remained in Fife; his son Joe ran the farm until a tractor accident in 1953. (Courtesy of Ron Mettler.)

Frank Albert Jr. is shown around 1925 in the hayfield with his horse, Duke. Frank was the father of two children—Jack and Beverly (Walsh), and the family home was on Goldau Road. After Frank's early passing, the home was sold to the Dacca family. (Courtesy of the Frank Albert family.)

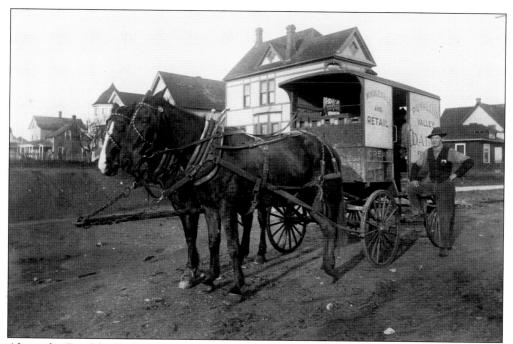

Alexander Fox (aka Fuchs) owned the Puyallup Valley Dairy, which was located in the area of Seventieth and Valley Avenues. Fox's brother-in-law, Frank Zurfluh, is pictured here making a delivery in the Tacoma area. (Courtesy of Georgine Salzmann.)

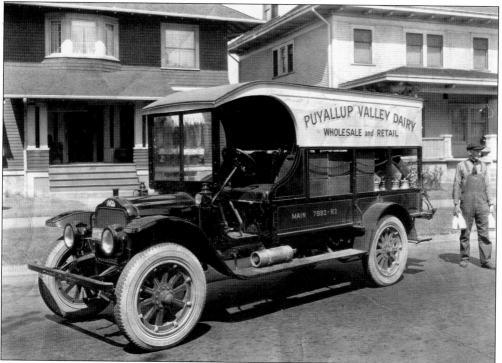

In later years, the Puyallup Valley Dairy would have Frank Zurfluh delivering milk with a different type of vehicle. (Courtesy of Georgine Salzmann.)

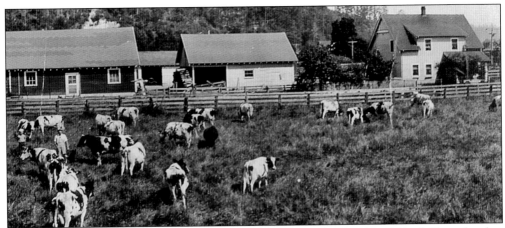

This is a portion of Model Dairy, which was established on Blue Road by Aldrich Fox, a brother of Alexander Fox. His previous dairy was the Golden Eagle Dairy—not to be confused with the Golden Rule Dairy that was owned by Joseph Kruger and was located near Marshall Road. (Courtesy of Bonnie Baxter, the daughter of Elizabeth Fox Dunning.)

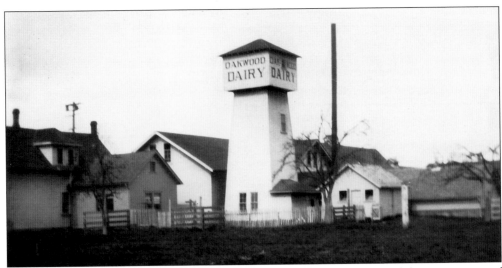

From its early days, Oakwood Dairy was located at the northeast corner of the intersection of Fifty-fourth Avenue and Twentieth Street. Andrew Ambuehl arrived in the 1890s and went to work for Flett Dairy in Tacoma. In 1906, he established Oakwood Dairy. (Courtesy of the Reichlin family.)

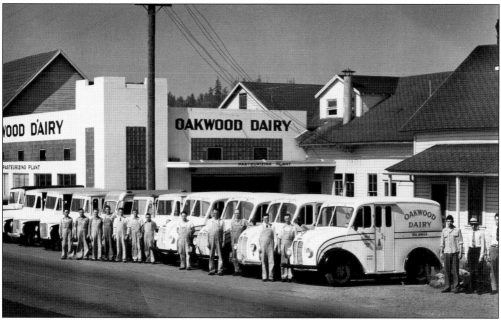

This photograph is probably from the early 1950s and shows Oakwood Dairy drivers lined up with their delivery trucks. Single men, most recent immigrants from Switzerland, worked for the dairy and lived at the farm. As their English skills improved, they might have the opportunity to take on a delivery route. When Oakwood closed, a number of the drivers found similar positions—some with Sanitary Cloverleaf Dairy in Firwood. (Courtesy of the Reichlin and Ambuehl families.)

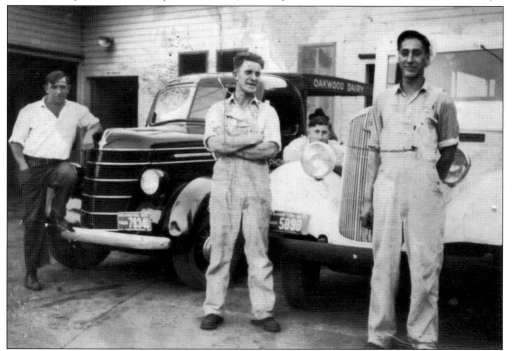

These are some of Oakwood's milk delivery drivers around 1946. The man on the far right is Jim Omegna Sr. (Courtesy of the Jim Omegna family.)

Valentine Ambuehl assumed responsibility for his stepfather's farm. When the freeway cut across his fields, the dairy operation moved to Valley Avenue, where it opened a modern processing plant. Unfortunately, this would be a short-lived operation. In 1968, the fairly new plant was closed and the delivery routes sold to Sanitary Cloverleaf Dairy in Firwood, which hired some of the Oakwood drivers. After 60 years in Fife, Oakwood Dairy, which had graced the Fife School campus with an easily detectable farm fragrance, would fade from the landscape. (Courtesy of the Valentine Ambuehl family.)

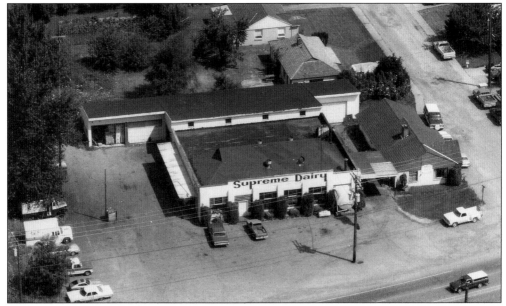

This photograph shows the processing plant for Supreme Dairy. This facility, located on Highway 99 south of the King County line, was built in 1949 by Frank X. Fischlin. It was also a supplier of dairy products to the Fife School District. (Courtesy of Rosie (Fischlin) DeTray and the Fife Historical Society.)

Pictured in his barn is Frank Schuler, who arrived from Switzerland in 1910. The Schuler farm was in the area of Blue Road and not far from Fifty-fourth Avenue. (Courtesy of Elice Schuler.)

On the smaller family farms, it was not unusual for the cows to have names, as they can exhibit distinct personalities. Here is young Tom Kaelin, brother of the author, with one of the cows in Vic Kaelin's herd. This photograph was taken around 1964, the final year for the family farm. (Courtesy of the Victor Kaelin family.)

In this photograph is the Martin Bingisser farm, which was located on North Levee Road between Fifty-fourth Avenue and Frank Albert Road. Martin initially worked for the Frank Albert farm and met his bride, Marie, at the nearby Baggenstos farm. (Courtesy of the Fife Historical Society.)

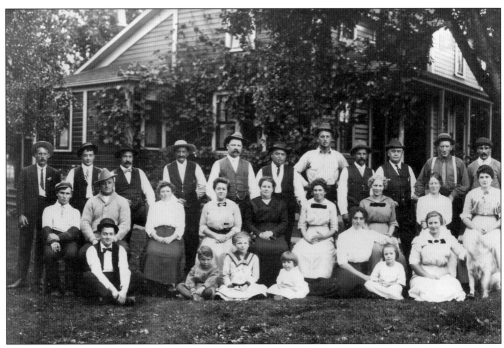

On Sundays, the Swiss families would often get together. This classic c. 1914 photograph depicts one of those Sunday gatherings with the families of Frank Albert, Martin Kaelin, and others. (Courtesy of the Frank Albert family and the Fife Historical Society.)

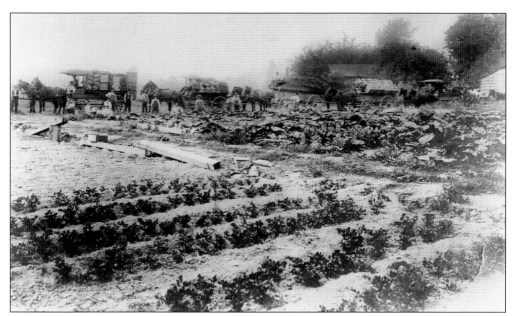

This 1905 photograph shows produce at Washington Gardens, the Ohashi family farm. The brothers had initially farmed with their brother-in-law, Heishiro Mihara, who was reported to be the first Japanese farmer in Fife beginning in 1897. The Ohashis grew potatoes and cabbage as well as carrots and other bunch vegetables. (Courtesy of the Ayako Ohashi Okubo family.)

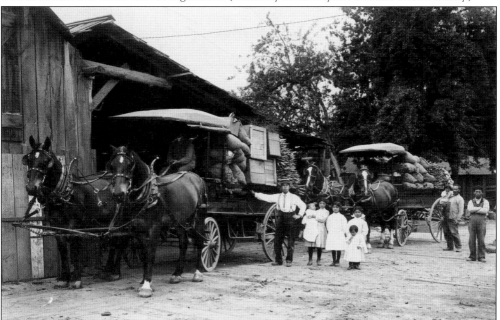

This photograph was also taken at Washington Gardens. In 1917, the opening of Camp Lewis brought about a sudden increase in Pierce County's population. Japanese farmers would leave Fife at 3:00 in the morning with their vegetable wagons to make delivery to the Army's mess halls. It was thought that lettuce would not do well in the valley, but Tokichi Ohashi took a chance and with great care produced a bountiful crop, one that satisfied the military's request. (Courtesy of the Ayako Ohashi Okubo family.)

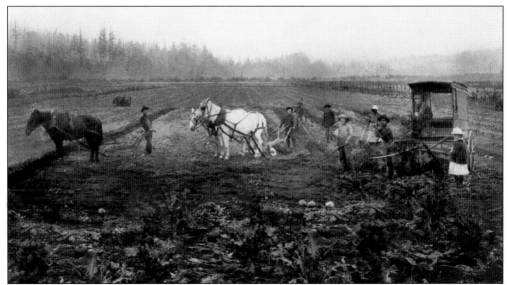

Umematsu Yoshioka, one of the men in this c. 1918 photograph, was born in the Hiroshima prefecture of Japan. When he arrived in the United States, he worked on the railroad for a year. He then became the foreman of a group of cannery workers in Bellingham. Yoshioka married Shige Maeda in Bellingham in 1907. Around this same time, he moved to Fife and began farming. (Courtesy of the Yoshioka family.)

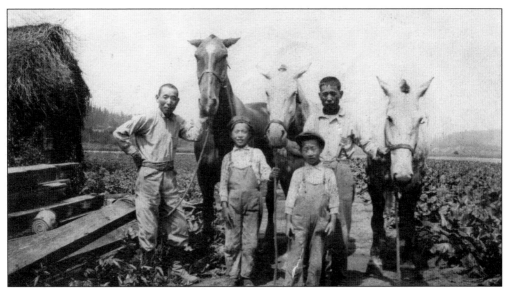

Umematsu Yoshioka (left) is pictured around 1918 with his and wife Shige's two sons, Daiichi and Juro (second and third from left). Also helping Umematsu on the farm for a while was his brother (right), who later returned to live in Japan. Daiichi and his family would maintain the operation of the farm for a number of years. (Courtesy of the Yoshioka family.)

Brookville was another early name for the Fife area—probably after the two creeks that traversed the landscape. Brookville Gardens was the name given to the farm operated by the Yotsuuye family. They have been displaced twice during their time in Fife, forced to move from their farm due to changes in Fife's economy. Toju (Tom) and Kazue Uchida moved from their first farm on Goldau Road to this farm on Valley Avenue. This is Tom on his tractor in 1957. His son, Tommy, continued to run the farm for a number of years. (Courtesy of the Yotsuuye family.)

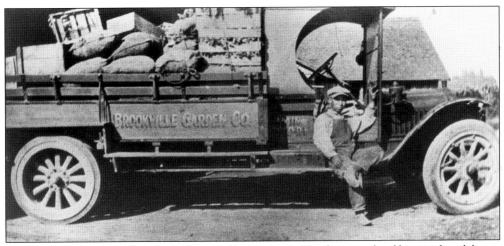

Naohiro Sasaki worked briefly for Brookville Gardens; this photograph of him with a delivery truck was taken in 1928. (Courtesy of the Yotsuuye family.)

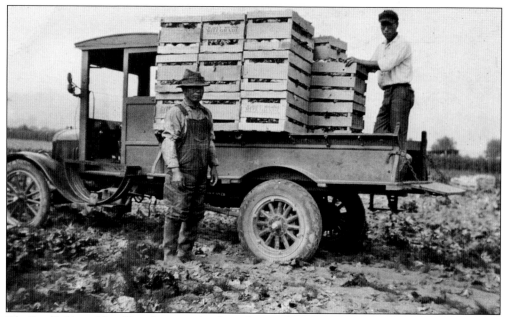

Chojiro (left) and Joe Kawabata are loading the truck in preparation for taking their crop to market. The Kawabata farm was near Levee Road and close to the Puyallup River. (Courtesy of the Kawabata/Kawasaki family.)

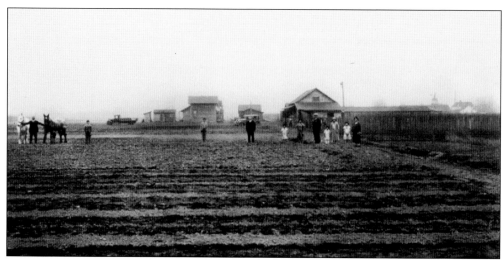

Member of the Chojiro Kawabata family are shown here on their farm. It may be that this photograph was taken to be sent to relatives in Japan to share evidence of the family's successful life in their new land. (Courtesy of the Kawabata/Kawasaki family.)

This is the home and farm of Hikozo and Rikuye Kawasaki as it appeared in 1938. (Courtesy of the Kawasaki/Kawabata family.)

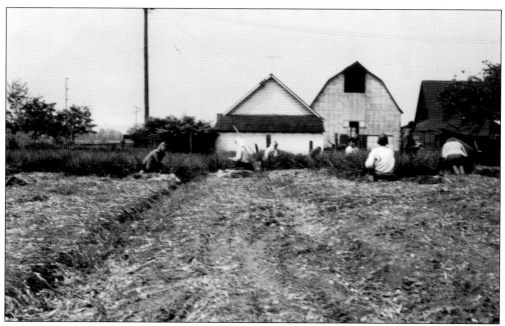

Shown here are workers in the Hikozo Kawasaki field in 1956. (Courtesy of the Kawasaki/Kawabata family.)

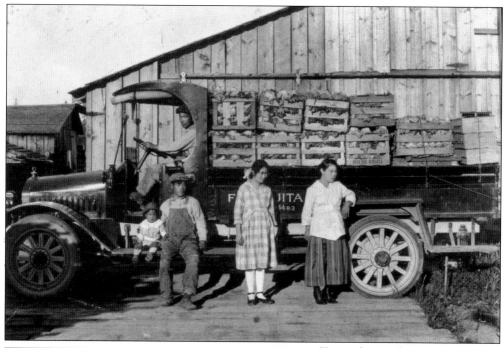

Kumaichi Frank Fujita is in his produce delivery truck, and his wife, Kimiko, is standing at the far right in this 1919 photograph. Their son Yosh is seated on the running board along with Kinichi, Frank's cousin. Masaye is Kimiko's sister and is standing to her right. (Courtesy of the Kumaichi Frank Fujita family.)

These unidentified youngsters are working on the Tamura farm, which was located near Hylebos Creek and Taylor Way (Fifty-fourth Avenue). Many growing up in Fife would spend summer days working in the field and developing a strong, lifelong work ethic. (Courtesy of Fujiko Tamura Gardner.)

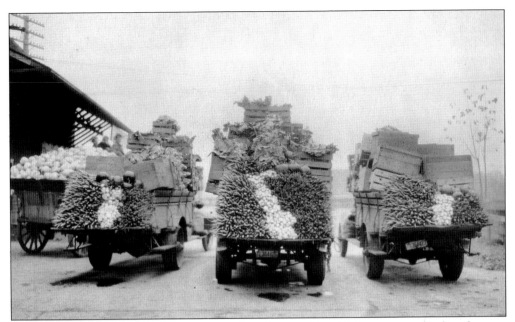

Colonial Gardens was officially incorporated on January 24, 1912, by a group of Italian farmers. Many had arrived by the early 1900s and had begun their cooperative venture closer to the Puyallup River, but they found it frustrating to deal with annual floods. They relocated closer to the area around Goldau Road, where one would have found these trucks loaded for market. (Courtesy of the Bevegni family.)

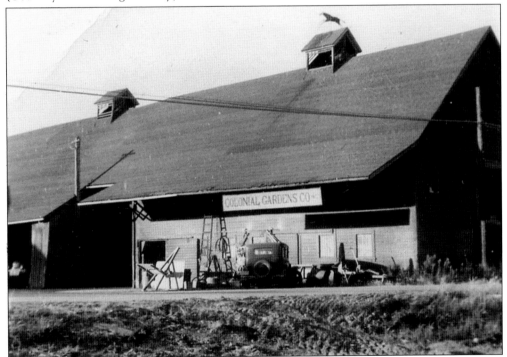

The main barn for Colonial Gardens was located near the intersection of Goldau Road and Twentieth Street. It had previously belonged to the Mettler farm. (Courtesy of the Bevegni family.)

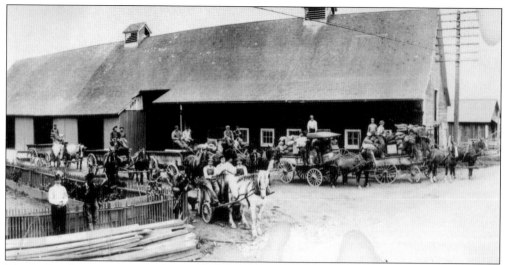

The Italian farmers are ready for another day's work with their horses and wagons. During the spring and fall, workers were called to work by the hitting of the *campana* (bell), which was actually a train rail hit with a sledge hammer. (Courtesy of Lucy Cerqui.)

Ralph Trucco, the uncle of Dorothy Canale Johnson Amrein, drove the horse team at Colonial Gardens. This photograph would have been taken sometime prior to 1926. (Courtesy of Dorothy Canale Johnson Amrein.)

Some Italians operated a garbage service in Tacoma before the city took control of this service. This photograph is of Joseph Garre, who lived on Goldau Road and would join the crew at Colonial Gardens. (Courtesy of the Edward Garre family.)

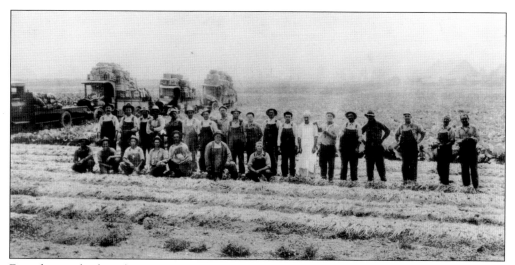

From front to back in this c. 1929 picture are GMC, White, Mack, and White trucks. Pictured are, from left to right, (first row) Louis Milano, Louis Dacca, John Pasinetti, Bob Bevegni, Joe Dacca, Louis Repetto, and Louis Trucco; (second row) Pete Milano, August Righetto, Joe Cereghino, Mechio, Baptiste Pasinetti, Louis Torre No. 2, Mike Santino (cook), Gaba, Angelo Bevegni, Ralph Bettinzoli, Lezzio Pesciallo, Angelo Boitano, Dario Pezzelo, Jack Torre, unidentified, Santo Parodi, Joe Garre, Nata, and Serefino Torre. There were two men by the name of Louis Torre at Colonial Gardens; they were referred to as Louis Torre No. 1 and Louis Torre No. 2. (Courtesy of the Dacca family.)

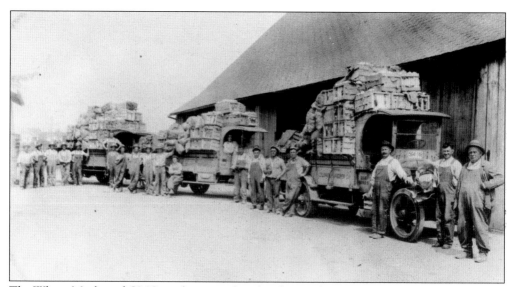

The White, Mack, and GMC trucks are ready to head to market. From left to right are Joe Dacca, Dario Pezzelo, Jack Torre, Santo Parodi, unidentified, unidentified (on truck), Louis Milano, Louis Dacca, unidentified, Bob Bevegni, Ralph Bettinzoli, Pete Milano (on truck), Nata, Gaba, Louis Torre No. 2, Joe Cereghino, Serefino Torre, Angelo Bevegni, and Louis Repetto. (Courtesy of the Dacca family.)

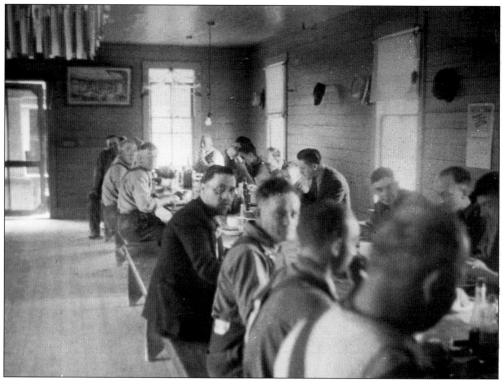

Breakfast, lunch, and dinner were served at the Colonial Gardens' dining hall. It was not unusual for guests to come for lunch—particularly members of the Tacoma police force. (Courtesy of Lucy Cerqui.)

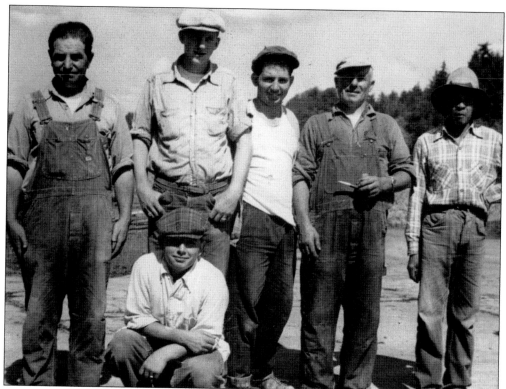

A number of Fife's high school students and other young adults would find summer jobs at Colonial Gardens. Pictured here around 1951, from left to right, are Ricardo Marzano, Fred Miller, Pete Tovoli, Dario Pezzelo, and Bernardo Pentolin, with David Tovoli kneeling. (Courtesy of the Pete Tovoli family.)

Guido Bini is shown here in one of the Colonial Gardens trucks around 1951; he may have just returned from his route to stores in the Grays Harbor area. (Courtesy of the Pete Tovoli family.)

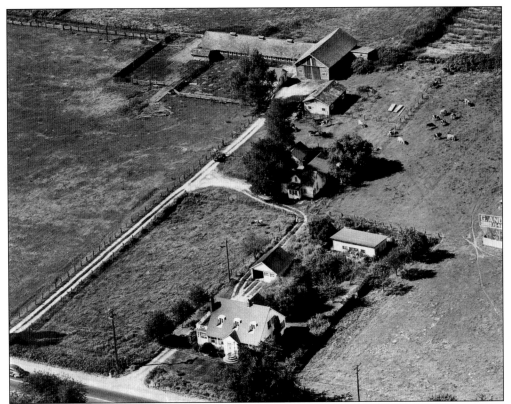

William and Esther Rystedt had a small farm off of Highway 99 near where the Port of Tacoma Road intersection is today. William had come to Tacoma from Sweden. The Rystedts would provide pasture for some of the Tacoma Fire Department's horses. Their newer home was closer to the highway and near the bottom in this c. 1925 photograph. (Photograph by Airphoto Services of America, courtesy of J. Rystedt.)

This shows the barn, the barn with the milking stations, and the milk house as well as the milk delivery truck. The Rystedts shipped their milk to Meadowsweet Dairy's processing plant in Tacoma. (Courtesy of J. Rystedt.)

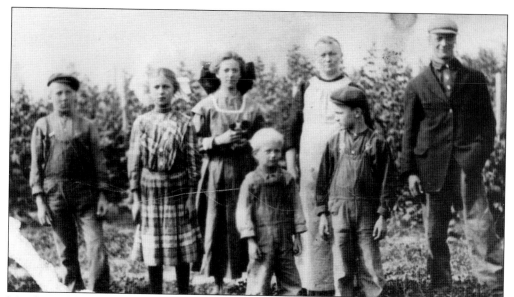

Members of the Olson family are out in the yard. Pictured are, from left to right, (first row) Arvid and Phillip; (second row) Henry, Esther, Anna, Albertina (mother), and John. Not pictured are August (father) or son/brother Fred. (Courtesy of the Arvid and Leah Olson family.)

Arvid and Leah Olson would farm this piece of property on Levee Road after the passing of Arvid's parents, August and Albertina. Mount Rainier sits in the background, and the bridge across the Puyallup River is visible on the right. (Courtesy of the Arvid and Leah Olson family.)

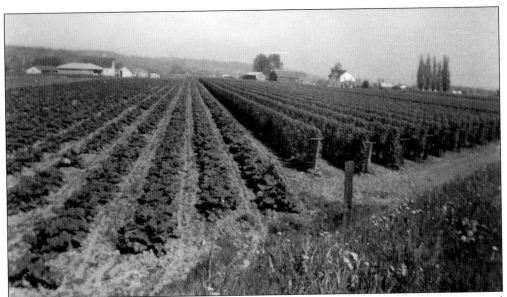

The Fred Carlson farm is to the left, while the Arvid Olson farm is to the right. The Olsons and the Carlsons planted and harvested corn on the nearby 35 acres belonging to the Kawabata and Kawaguchi families while they were interned during World War II. (Courtesy of the Arvid and Leah Olson family.)

This looks like a scene for a holiday card. This Olson residence was built in 1903; the family's first home had been a cabin. The Radiance development is in this area today. (Courtesy of the Arvid and Leah Olson family.)

These boys learned that in order to prepare a field, one would need a tractor and a plow. Shown here are Dean (left) and Joel, the sons of Fred Carlson. The Carlson farm was located on Levee Road and was later purchased by Jack and Jeanne Crowell. (Courtesy of Joel F. Carlson.)

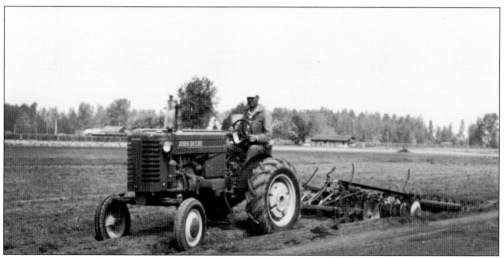

After plowing, the farmer puts another attachment on the tractor—the disc harrow, as demonstrated by Fred Carlson. In later years, rhubarb, cucumbers, and berries could be found in these fields. (Courtesy of Joel F. Carlson.)

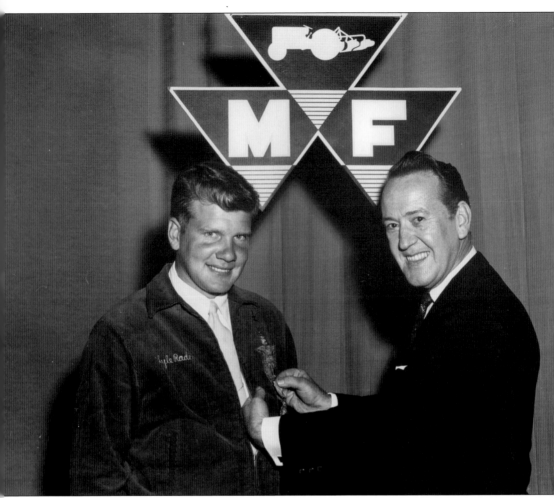

Lyle Rader was a graduate of Fife High School and a Future Farmers of America (FFA) member from his freshman year. In October 1959, at age 21, Lyle was honored with the FFA's oldest and most prestigious award, Star Farmer of America, at the national convention in Kansas City, with Red Foley making the presentation. Rader was recognized for his leadership, citizenship, and scholarship. Within 10 years of this award, Lyle was president of the Fife School Board. One of his innate abilities was that of improving upon equipment in ways that have been duplicated throughout the industry. At the time of this recognition, Rader was in business with his mother. Lyle went on to take Rader Farms Inc. from a small family farm to one of the nation's leading producers of berries. Rader Farms's berries are distributed internationally through successful partnerships with Costco, Safeway, Jamba Juice, and others. Lyle relocated twice after farming in Fife, and he retired to Camano Island before his passing in April 2010. His son, Brad, now provides the leadership of Rader Farms in Lynden, Washington. (Courtesy of the Lyle Rader family.)

Four

FIFE SCHOOLS

In December 1899, seven youngsters— Gus, Frank, Virginia, and Caroline Erspamer; Kate Albert; Fred Roseli; and Paul Vanderschelden—became students at District No. 88. Henry Sicade had been an advocate for establishing a district, and Frank Albert, Carl Mettler, and Jerry Meeker were the residents elected to be the district's directors. Within the next year, land was purchased from Alfred Tenzler, and a two-room facility was built in the vicinity of the current Fife High School. The enrollment was up to 24 students with two teachers. By 1905, the district opened a two-story building, hired a principal, and added three teachers.

During these early years, students of high school age made their way to Tacoma. When the Tacoma district sought to absorb all of Fife's students, a court decided that Fife would continue as a separate district, and its boundaries were extended. With this determination came additional funding; Fife added an auditorium to its site in 1912, and the school was able to purchase books for the students. The reapportionment of district boundaries also allowed Fife to establish its own high school, and in 1916, the graduation of two young women was celebrated.

The first brick school was built in 1930 and served as the high school. Today, it is the oldest structure still on the main Fife campus. Another brick building was constructed in 1932 and served as the elementary school, the intermediate school, and then the district's offices until it was demolished in 1992.

The covered wood stadium was constructed in 1946, and in May 1950, a new high school building was dedicated. In 1954, a primary school at the east end of the campus opened; this currently serves as the district's central offices. School officials and students would celebrate the dedication of a new gymnasium in 1957. In 1961, a building containing a cafeteria, full kitchen, and large music facility was opened. In 1962, new tennis courts were poured, and the FFA barn that can still be viewed from I-5 was constructed. Although renovations have taken place over time, most of these structures are still in use today.

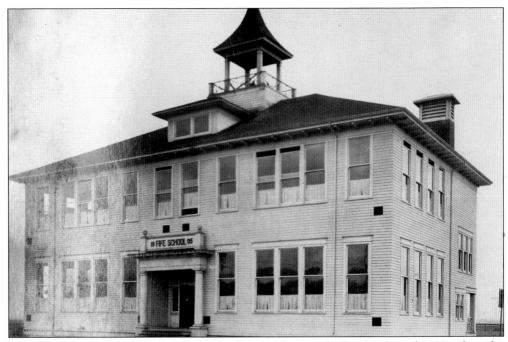

This building, completed in 1905, was used as the district's high school until 1930, when the district's first brick structure was completed. This photograph was taken in 1913. (Courtesy of Brian C. Payne.)

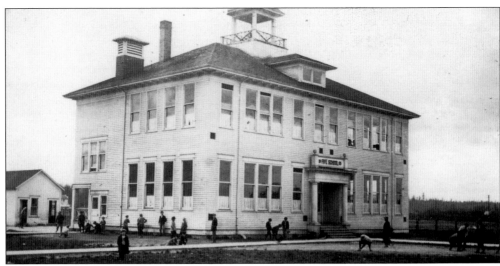

This is an image of the same building taken from a different vantage point. In the *Polk's 1915–1916 Pierce County Directory*, School District No. 88 was identified as Brookville. During this same time period, the *Tacoma Times* newspaper referred to the school as Gardenville. The name Fife, obviously, took hold over time. (Courtesy of the Gustaf Peterson family.)

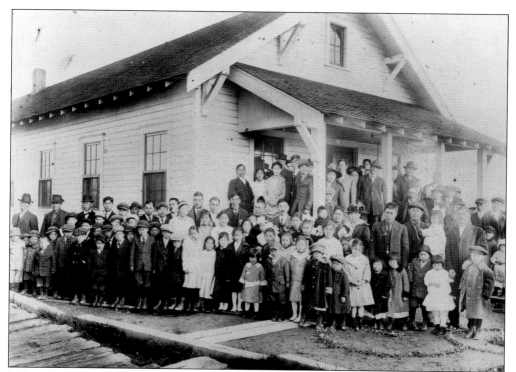

In June 1909, some 16 Japanese farmers gathered for the purpose of forming a Japanese-language school in Fife; the building was constructed in 1912. Japanese American students would attend regular classes in Fife Schools and then go to the language school for an hour after school each day and for three hours on Saturday. (Courtesy of the Ayako Ohashi Okubo family.)

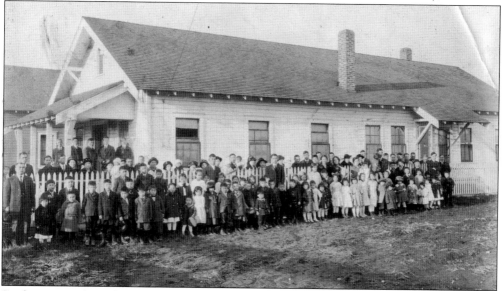

Students attending the Fife Japanese Language School would learn how to communicate in Japanese—both orally and in writing. This way they could stay in touch with family members in Japan. There were similar schools in Tacoma and nearby Firwood. (Courtesy of the Kawasaki/Kawabata family.)

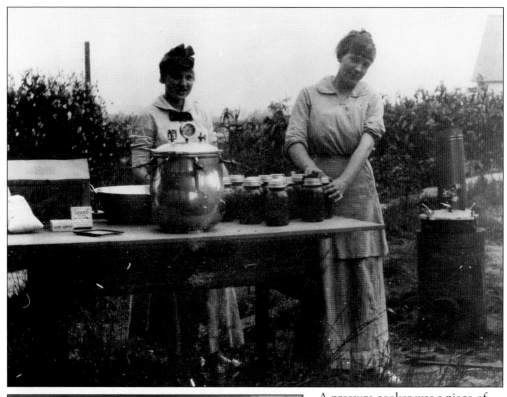

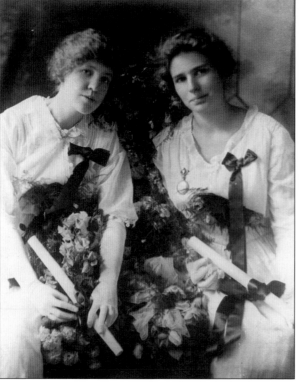

A pressure cooker was a piece of equipment that the school had acquired by August 1915, and students learned to use it—in this case for the canning of green beans. Fife students were the ones who demonstrated the use of the pressure cooker, the first one in the county at this time, at the Puyallup Fair.(Courtesy of Brian C. Payne.)

The first graduation took place in 1916, and the two graduates were, from left to right, Helen Peterson (Payne) and Sarah Garman (Telling). Charles Sicade was the only male to graduate from Fife in 1918, and Clarence Peterson would be the next male to graduate, in 1921. (Courtesy of Brian C. Payne.)

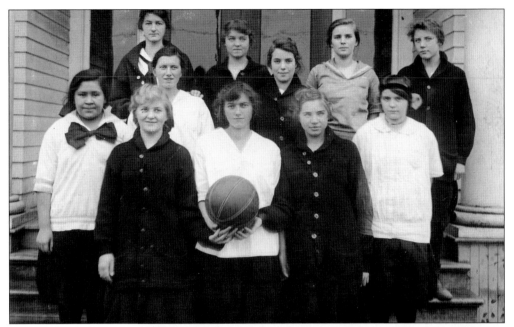

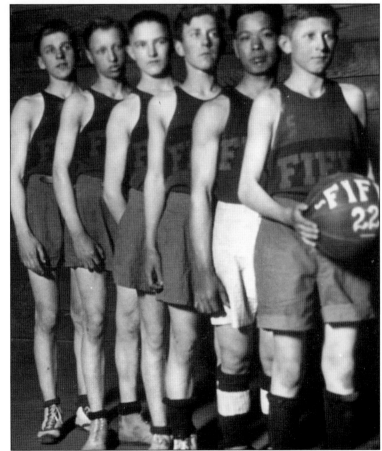

Girls enjoyed playing basketball back in 1916. According to an article from an October issue of the *Tacoma Times*, the school had a well-lit basketball court in the basement. (Courtesy of Brian C. Payne.)

Here is the boys' basketball team at Fife in 1922. (Courtesy of Brian C. Payne.)

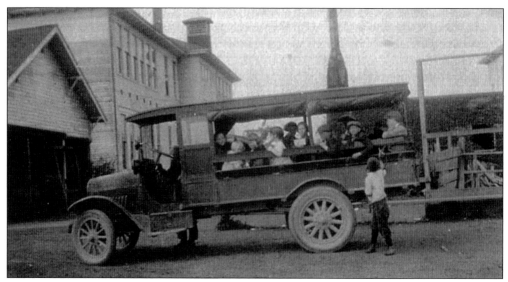

In 1924, a school bus would have looked something like this. A high school student might have been the bus driver. (Courtesy of the Stener Thorson family.)

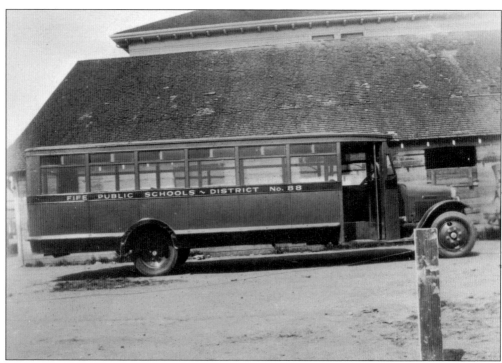

Given some time, school buses would surely improve, as is evidenced by this photograph. (Courtesy of Lucy Cerqui.)

Here is the Fife High School basketball team in 1925. Identified players are Edward Kaelin (first row, second from left) and Daiichi Yoshioka (first row, far right). (Courtesy of the Yoshioka family.)

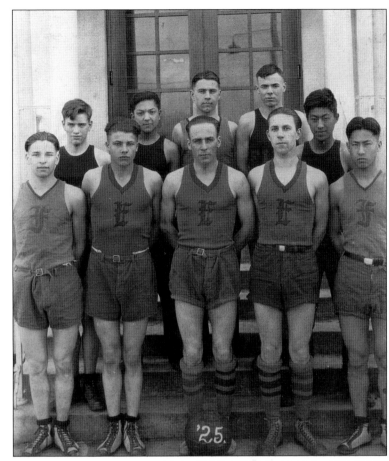

These are Fife High School's baseball players in 1925. Many of the athletes typically played more than one team sport. Careful examination of the image reveals a cow in the background to the left. (Courtesy of the Yoshioka family.)

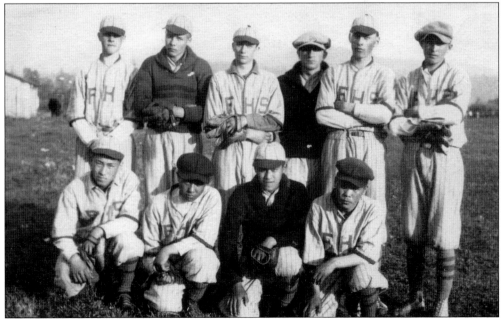

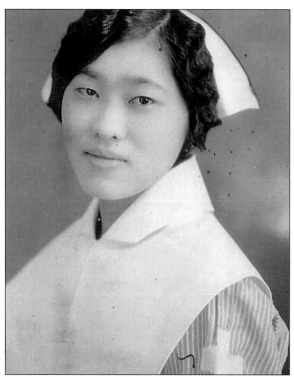

Katsuko Watanabe was the second Japanese girl to graduate from Fife High School; she went on to be the first Japanese American to receive a registered nurse's degree in 1927. Her younger brother, James Michio Watanabe, would attend medical school and serve as a pathologist at Sacred Heart Hospital in Spokane for nearly 30 years. (Courtesy of the Akagi family.)

The class of 1928 had 27 members when they were freshmen, as shown here. Illness and other mishaps would result in just nine of the students graduating: James Anderson, Thomas Beksinski, Johnny Fujita, Clyde Garman, Ester Hill, Folke Johnson, Mitsu Kawamoto, Ayako Ohashi, and Ruth Thorson. (Courtesy of the Ayako Ohashi Okubo family.)

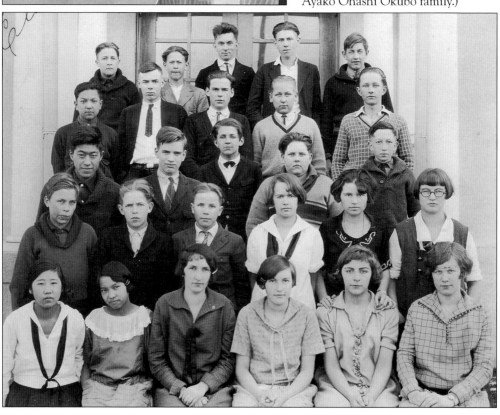

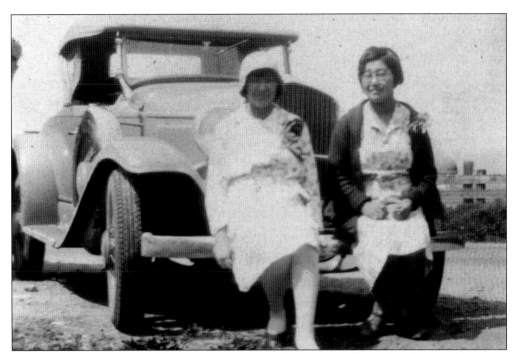

Kazue Uchida (left) and Michi Sagami are sitting on the bumper of Harry Enochs's car. Harry was a principal, teacher, and coach at Fife High School. He formed the first football team and took the baseball team to the state championship in 1929. (Courtesy of the Yotsuuye family.)

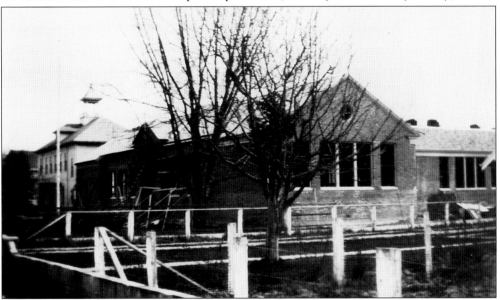

This photograph by Ferdy Reichlin Sr. shows the 1932 construction of the elementary school. One of the more notable features of this building was the kindergarten room, which was quite spacious and designed with young children in mind. This structure was positioned at the west end of the campus when all of the schools were located in a stretch of property aligning Twentieth Street. Another building at the east end of the campus would later house grades one, two, and three. (Courtesy of the Reichlin family.)

Mitsuko Kawasaki (left), Shiz Yamada (center), and Haruko Yaguchi are shown around 1937 in the area of the elementary playground behind a couple of the school buildings on the Fife campus. (Courtesy of the Kumaichi Frank Fujita family.)

Goro Kuroda (left), Eigi Yamada (center), and Bill Mizukami are also found on the grounds behind the school buildings around 1937. Bill was the brother of Bob and Frank, who operated the Gardenville Greenhouses. Bob volunteered to serve during World War II, and he instructed his brother to stay behind and care for their parents. Unfortunately, Bill did not follow his brother's advice, and he was one of the many who did not return from the European front. (Courtesy of the Kumaichi Frank Fujita family.)

On the first day of school around 1942, neighbor boy Louis Boitano has volunteered to walk Norm Cronquist to school for his first day of kindergarten. Louis is the son of Angelo "Andy" and Victoria (Dacca) Boitano. (Courtesy of the Andy Boitano family.)

Here are the members of Beaver Patrol Troop No. 57. They are, from left to right, Bob Moser, Odell Wallace, Jack Kotchkoe, Travis Wallace, and Louis Boitano. Their scoutmaster was Ed Burke, who later became Louis Boitano's father-in-law. They are pictured here around 1945 to the west of the elementary school, which was constructed in 1932. (Courtesy of the Andy Boitano family.)

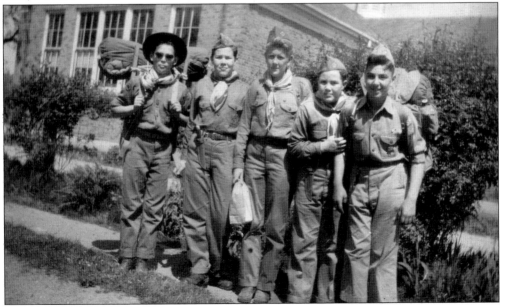

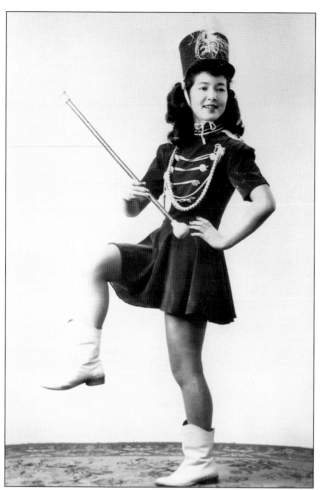

Mary Ueda, the youngest of the Ueda family, is ready to show her baton twirling talents for a school event. Mary graduated from Fife High School in 1948. Her brother Herbert Ueda faithfully travels from New Hampshire to visit friends in the Fife area annually. (Courtesy of Herbert Ueda.)

The Fife School District's auditorium, west of the high school building constructed in 1930, consisted of a stage, balconies that ran parallel to the floor and above the locker rooms, and a wooden basketball court. Chairs were used for performances requiring the stage. Once the new gymnasium opened in 1957, the old gymnasium provided space for special activities, rainy-day recesses, and PE classes conducted by classroom teachers. (Courtesy of Marion Iversen Butler.)

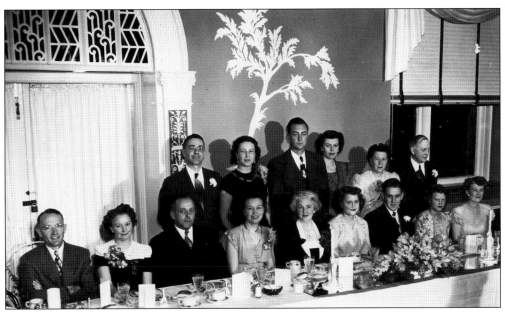

Seated, from left to right, at the 1949 junior-senior dinner dance are Marvin Belknap, Fife High School principal (1945–1970); Mrs. Belknap; Robert C. Hall (for whom the gymnasium is named), Fife Schools superintendent for 29 years; Mrs. Hall; longtime English teacher Arlene Lindstrom; class officers Annie Issacson, Bob Norris, and Wanda Leffler; and Miss Dunn, longtime librarian and teacher. Standing, from left to right, are parent chaperones Roy and Pat Andre, faculty chaperones Mr. and Mrs. Sorenson, and parent chaperones Mr. and Mrs. Norris. (Courtesy of the Andre family.)

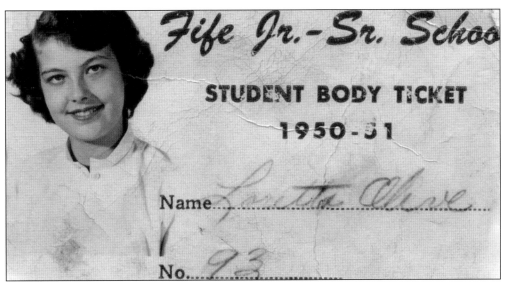

Shown here is Loretta Olive's ASB (Associated Student Body) card for 1950–1951. Loretta married Jack Murrey; their daughter, Sherri, was crowned the Daffodil Queen for the annual festival in 1973—the first Fife princess to achieve this honorable position. Sherri's Aunt Diane was a princess in 1959 on Fife's first community float. (Courtesy of Jack Murrey.)

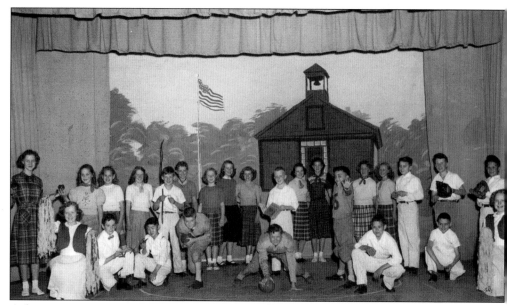

A dramatic yet entertaining program was presented by some Fife Elementary School students back in the early 1950s. Based upon the way in which the students are dressed, one might draw the conclusion that the performance was about school life. (Courtesy of Diane Murrey Robinson.)

The Fife High School Class of 1935 is shown here in 1965 at its 30th class reunion. Members had a dinner and dance at the Top of the Ocean restaurant in Tacoma. Fife's first mayor, Joe Vraves, is fifth from left in the first row. (Courtesy of the Takashi Kurimoto family.)

Five

FIFE BUSINESSES

Fife began as a farming community in the 1890s. Travel was by horse and wagon, and the roads were no more than paths leading to and from nearby communities. In May 1900, the first post office in Fife was established, and James A. Stryker was named the postmaster. This office closed at the end of that year, and the local post office moved to Edgewood.

On February 13, 1901, a post office opened at Klink and Weisser's general mercantile at "a village of Swiss settlers," as described in Guy R. Ramsey's *Postmarked Washington: Pierce County*; but it was closed exactly two years later. The local postal office was moved to Puyallup.

Jessie Dyslin apparently assumed responsibility for the store after the departure of Klink and Weisser. Although she had been married and had children, Jessie was a businesswoman, and her life focused upon her work. After a couple of years in Fife, she returned to Tacoma and operated a restaurant.

The interurban, which began operating in 1902, prompted more people to settle in Fife. An increasing population presented opportunities for those desiring to establish businesses, and the center of the business district was at the intersection of Twentieth Street and Fifty-fourth Avenue—Fife Square. This is where Ben Andre would establish Andre's Market in 1905.

Arthur Erspamer was an early pharmacist in Fife, but he would move on to Tacoma and Seattle. Tacoma native Ernie Sowders and his wife, Linnea, opened the Fife Pharmacy in a building owned by the Kibe family in the 1920s. The Kibes operated a produce company at Fife Square.

The opening of a paved highway connecting Tacoma and Seattle in 1928 caused the center of the business district to gradually relocate to the intersection of Highway 99 and Fifty-fourth Avenue. It was at this location that a restaurant opened its doors in 1933 as the Poodle Dog. This establishment remains a Fife landmark.

On June 1, 1936, the Fife Rural (Station) Branch of Tacoma was established, and Ernest Sowders, the pharmacist, was the clerk in charge. This postal station was placed in the rear of the drugstore and consisted of a desk surrounded by a wicker barrier with a small window.

In 1949, a used car salesman's office, west of the main business district, was converted into the iconic Pick Quick, still one of the best places to get a hamburger or a shake of any flavor.

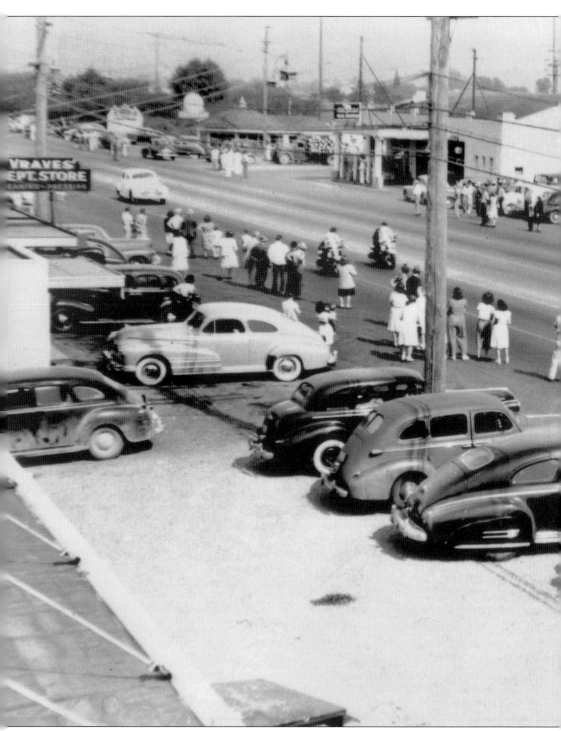

It is not known whether this parade was connected with a campaign tour for Harry Truman, or if it was when Douglas MacArthur rode through town. What this mid-1940s photograph (possibly taken by Andy Vraves, brother of Fife's first mayor) captures is the new Fife Square—the intersection of Highway 99 with Fifty-fourth Avenue. Across the highway from Vraves' Department Store and

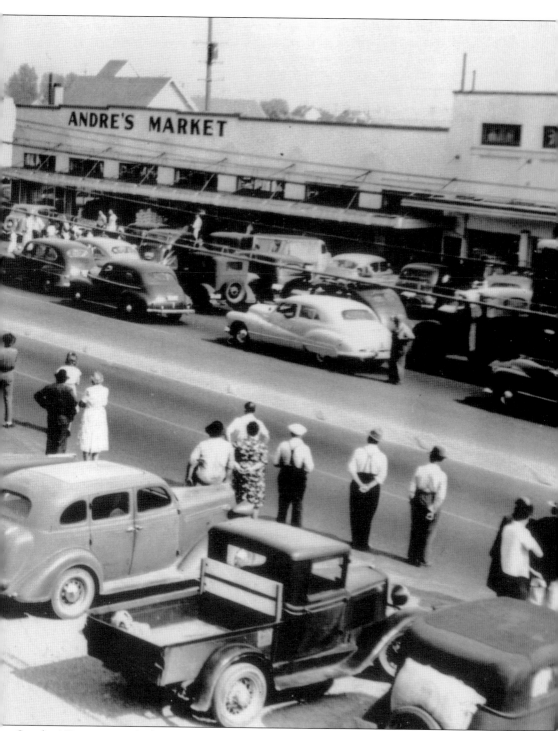

Sowders' Drugstore is Andre's Market. To the east of the market is what is the Valley Forge gas station, and across the street to the east is the uniquely shaped White Spot Tavern. Across the highway from the White Spot is the Gallert's service station. Behind the store is the Fife Chapel, which faced Fifty-fourth Avenue. (Courtesy of the Sowders family.)

Young, dapper Ben Andre came to Tacoma from Ohio in 1902. He was equipped with salesman skills and experience, which he put to work for the Tacoma Grocery Company. Having this position allowed him to get to know the area and the shopkeepers. The opportunity arose in 1905 for Ben to open his own store, which he did in the Fife Square. (Courtesy of the Andre family.)

Ben Andre's, "The Store That Has It," was originally housed in the building to the far right in this photograph. For a number of years, the fountain was situated in the center of Fife Square and was intended to be used for watering horses. The water was drawn from a nearby artesian well, which was also used by Oakwood Dairy. Fife's fountain has been moved a few times during the past century, but it can now be found near the entrance to the Fife Swimming Pool. (Courtesy of the Andre family.)

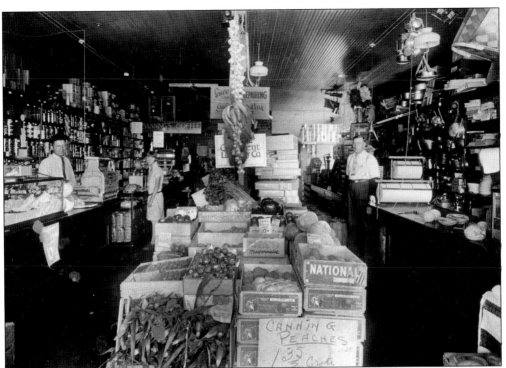

This photograph shows the inside of Ben Andre's early store. Ben knew his customers and their potential needs in this growing farming community, and he was well equipped to meet them. Ben and Clara Andre made Fife their home, and their children graduated from Fife High School. Ben also served on the Fife School Board for a period of time. (Courtesy of the Andre family.)

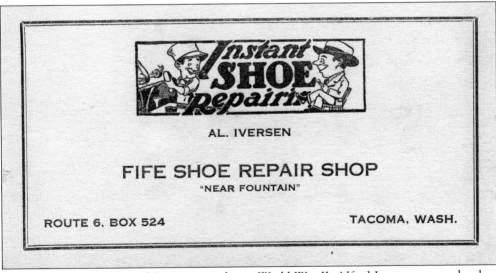

From 1922 until the United States entered into World War II, Alfred Iversen operated a shoe repair store in a small lean-to attached to the original market building owned and operated by the Andre brothers. Alfred had learned the trade from his father, who had a shoe business in Tacoma. Alfred married Henrietta Benthien, and they were the parents of a daughter and four sons, three of whom served in World War II. (Courtesy of Marion Iversen Butler.)

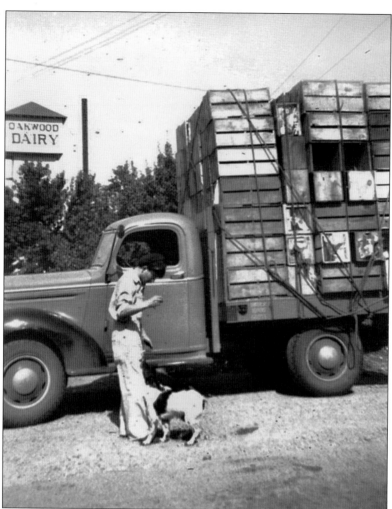

On the south side of Twentieth Street and not far from the main intersection was Kibe's produce warehouse. This photograph shows Joseph Kibe with Duke, the family dog, next to a truck. The Oakwood Dairy water tower is in the background. (Courtesy of Himiko Kibe and the Kibe family.)

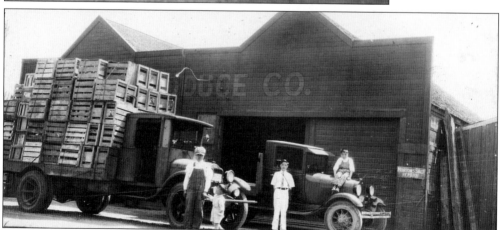

The Kibe truck is in front of the warehouse as are some Kibe family members. The Kibe family did not return to Fife following World War II. Massy Kibe, one of the sons, operated a produce company in the Portland area after the war. (Courtesy of the Kibe family.)

The large horseshoe sign in this c. 1915 photograph reads Houston and Hubbert, but the local blacksmith shop—certainly a necessity in a community of farms—was also known as Valley Forge. Robert L. Houston had come west from Tennessee, while Henry Hubbert made the trip from New Jersey. The young boy in this photograph is Robert L. Houston Jr. (Courtesy of the Robert L. Houston family.)

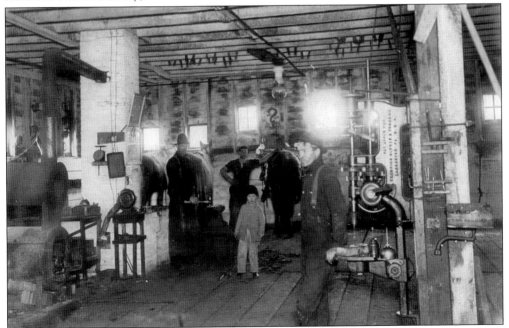

This c. 1915 photograph captures the inside workings of an early-20th-century blacksmith shop as established by Houston and Hubbert. Young Robert Houston would go on to graduate from Fife High School, live in the community, and eventually work as a mechanic for the Fife School District. (Courtesy of the Robert L. Houston family.)

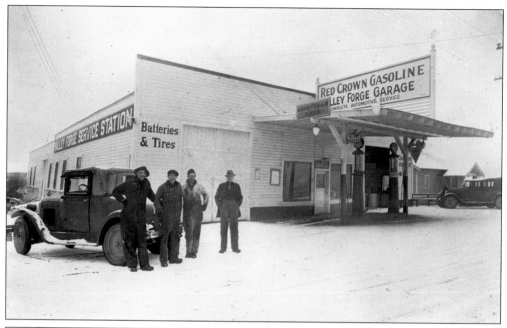

Once motor vehicles became the primary mode of transportation, the Hubbert family exchanged the blacksmith shop for a service station. (Courtesy of the Fife Historical Society.)

Orchard Station was an early Flying A Associated service station in Fife. It was located at approximately the 6800 block of Highway 99 and was owned by Clarence, Eldon, and Winston Peterson. Pictured here are Clarence and Ruth Peterson. Gustaf and Anna Peterson, the owners' parents, lived nearby. Dick Johnson ran this station for a number of years after the Petersons sold it. (Courtesy of the Gustaf Peterson family.)

Ora Murrey had a saw-sharpening business in Fife. It was located on Twentieth Street near Fife Schools and Kibe's Produce Company. The Murrey home was one of seven lost in the fire of 1935. Ora's second son, Jack, later became a leader among Fife's volunteer firefighters. (Courtesy of Jack Murrey.)

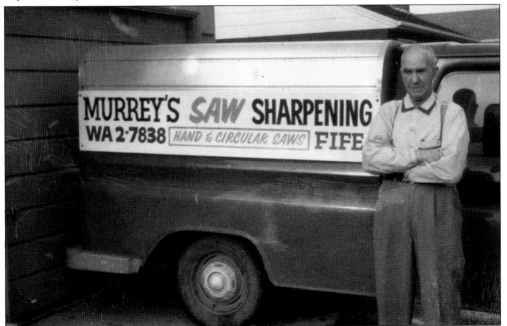

After 40 years of saw-sharpening, Ora Murrey turned the business over to his second son, Jack, who had this truck at the time he took over. Murrey's grandson, David, would establish David Murrey's refuse business, which had only one other major private competitor in Pierce County—Harold LeMay's company. (Courtesy of Jack Murrey.)

In later years, near the northwest corner of Fifty-fourth Avenue and Twentieth Street, Jim Novak would be the blacksmith in Fife. His business provided welding, blacksmithing, and clothesline poles. The address was listed as Fountain Square, Route 2, Box 93, Tacoma. His longtime pickup truck is seen in front of his first shop, which is next to another store at the time, the Red Ladder. (Courtesy of Frank Schnider.)

Just east of Novak's blacksmith shop were a Mobil gas station and Fife Fuel Oil, which was owned by Frank Schnider, one of the first city council members. Schnider had earlier been in partnership with Manuel Mello, who previously partnered with Rex Merrill. Bill Tschudin purchased the facility from Schnider. Not long after the freeway opened, there were five gas stations at the site of the old Fife Square. (Courtesy of Frank Schnider and the Fife Historical Society.)

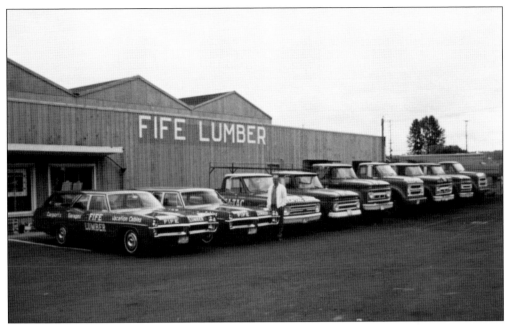

Fife had a lumber store at the southeast corner of the old Fife Square. In 1960, Union 76 purchased the property for a gas station, but Stan Beattie, the manager of the store, wanted to remain in the lumber business. He entered into a partnership with a Puyallup firefighter, Al Meier, who would initially work at the store on his days off. Valentine Ambuehl sold Beattie and Meier two acres for their store. (Courtesy of Al Meier.)

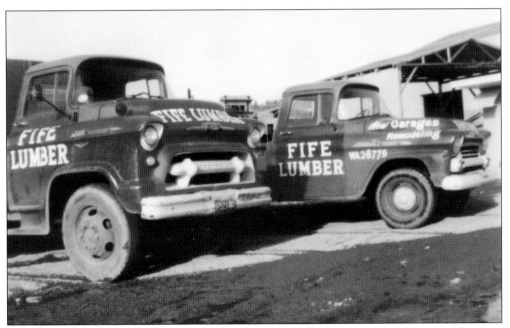

Stan Beattie's life span would be cut short, but Al Meier demonstrated an innate good-business sense and continued to oversee the operation of Fife Lumber as well as its expansion into six other communities until 1990, when it was sold to Lumbermen's. (Courtesy of Al Meier.)

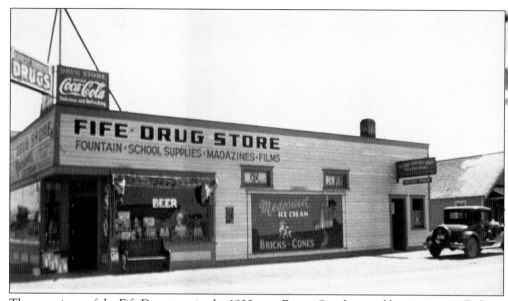

The proprietor of the Fife Drugstore in the 1930s was Ernest Sowders, and his young son, Robert, was his designated helper. The store was located on the southeast corner of Twentieth Street and Fifty-fourth Avenue. Customers could enjoy a dish of ice cream or a soda at the soda fountain. (Courtesy of the Sowders family.)

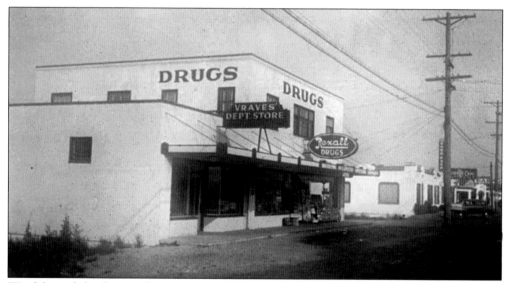

Wind fanned the flames of one of the worst fires to hit Fife. The drugstore was just one of the structures totally destroyed by the 1935 blaze. The Sowderses made an agreement with the Andre family to allow them to fill prescriptions out of their store while the family constructed a new building at the current location at 5303 Pacific Highway East. This photograph from the late 1940s also shows the Vraves' Department Store just west of the drugstore. (Courtesy of the Sowders family.)

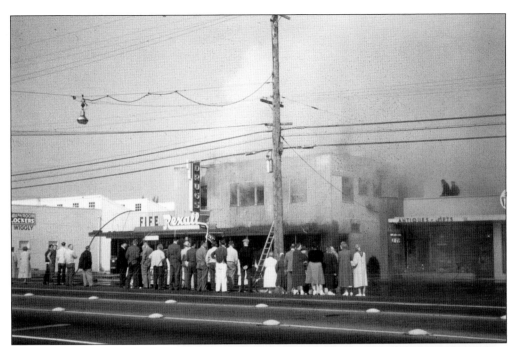

Fire struck the Sowders again in October 1958, as pictured here. This fire was started by a sterilization unit in one of the doctor's offices upstairs. A gift and antique shop is just east of the drugstore. (Courtesy of the Sowders family.)

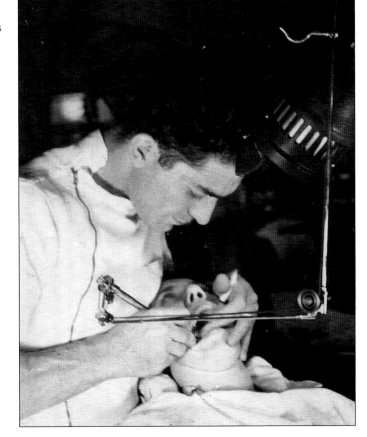

This photograph shows Dr. Joseph Parosa when he was still in dental school in Oregon in 1944. After a brief stint in Tenino, he would move to Fife and have his first office on the second floor of the drugstore. (Courtesy of the Joseph Parosa family.)

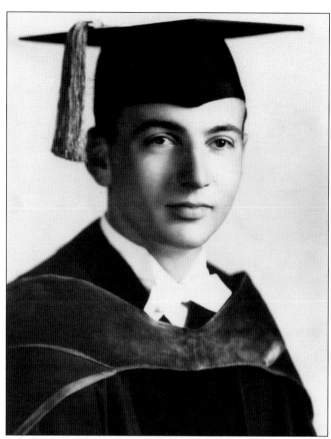

The doctors who worked in the offices above the drugstore were Dr. Leo Sulkosky and Dr. Hugh Kalkus. At left is Dr. Kalkus at the time of the completion of his degree in medicine. He met his wife when he was a patient at a hospital and she was a nurse there. He told a good friend upon seeing her the first time that he was going to marry her. (Courtesy of the J. Hugh Kalkus family.)

During the 1950s, Dr. Parosa and Dr. Kalkus decided to construct a small brick medical facility on Valley Avenue. Dr. Sulkosky moved to Puyallup and practiced medicine there, while Dr. Jack Scott joined Dr. Parosa in the practice of dentistry at the new office. (Courtesy of the J. Hugh Kalkus family.)

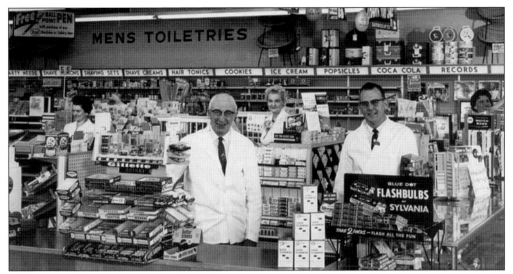

Inside the drugstore in 1949 are, from left to right, Ernie and Linnea Sowders and their son, Bob. Robert joined the business with his parents in 1947 at the completion of his studies. Bob and Maxine Sowders were always on duty for the community until April 1985, when they sold Fife Rexall Drugs to David Morio, who faithfully served the community for the next 25 years. As of 2011, the building that was home to the drugstore for so many years is still there, but it no longer houses a pharmacy. (Courtesy of the Sowders family.)

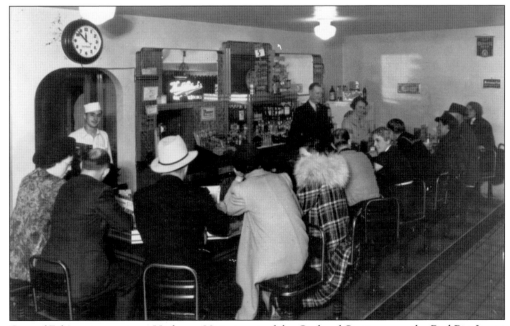

One of Fife's restaurants on Highway 99, just east of the Orchard Station, was the Red Pig. It was opened in May 1937 and was operated by Earl Smith. The managers at this time were young Joe Fox and his sister-in-law Bernice. Joe was the son of Aldrich Fox of Model Dairy. (Courtesy of the Tacoma Public Library, Richards Studio Collection, A7529-1.)

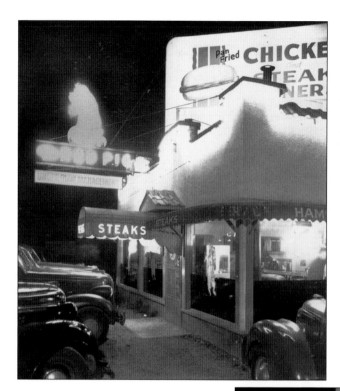

In later years, the Red Pig (the sign is pictured here in 1938) would become Nicky's Tavern, owned by Nick Radonich, who also owned the White Spot Tavern for a period of time. Both buildings have been gone for some time. (Courtesy of the Tacoma Public Library, Richards Studio Collection, A7529-4.)

In 1933, two friends from Tacoma, Mac Manza and Jimmy Zarelli, purchased the Blue Jay, a hamburger place in Fife with 10 stools and a couple of booths. Mac Manza had been to a fancy, historic French restaurant in San Francisco called Ritz's Old Poodle Dog. This dining experience caused Mac to come up with the name of the Poodle Dog for the restaurant. The ever-present Poodle Dog icon can be seen in the sign for this 1939 building. (Courtesy of the Fife Historical Society.)

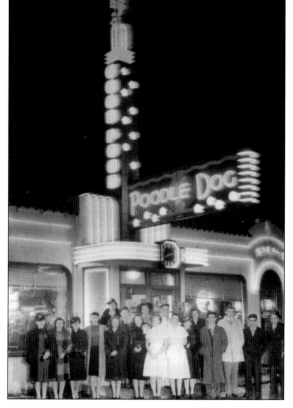

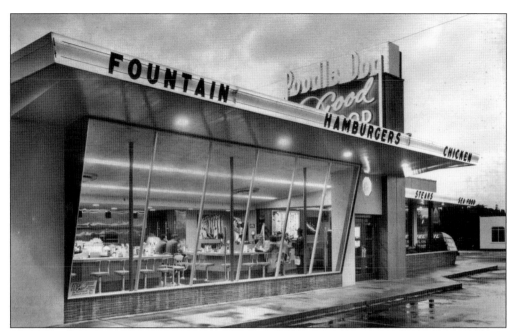

In 1949, a more modern incarnation of the Poodle Dog, seen in this May 1951 image, was constructed with slanted windows. Once Fife was incorporated in 1957, the city council decided to have its council meetings in the Poodle Dog's banquet room. (Courtesy of the Tacoma Public Library, Richards Studio Collection, A45142.)

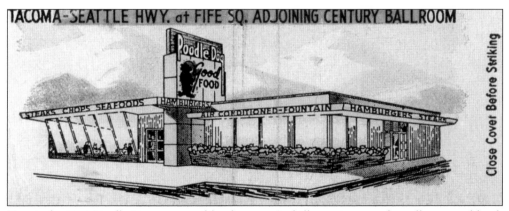

Here is the 1949 Poodle Dog on a matchbook cover. A phillumenist, one who collects matchbook covers, would be able to estimate the value of this or any similar find. (Courtesy of the Fife Historical Society.)

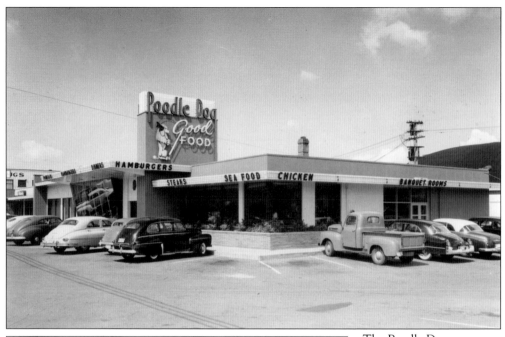

The Poodle Dog restaurant would undergo another renovation in 1967. Here is another look at the 1949 Poodle Dog, with its sleek windows and bar stools at the counter. Manza and Zarelli have been gone for a while, but their Poodle Dog restaurant lives on. (Courtesy of the Tacoma Public Library, Richards Studio Collection, A45142.)

In time, Ben Andre's son, Roy, would take over the operation of Andre's market. Pictured here are Roy seated; his wife, Pat, on the left; his daughter, LaRae; and his sons, Bill (left) and Ben. Roy was one of the Fife residents to help some of the Japanese families while they were interned in Minidoka, Idaho. (Courtesy of the Andre family.)

Some of the employees of Andre's market from the first half of the 1940s pose in front of the store. The third gentleman from the right is Roy Andre, the son of founder Ben Andre. (Courtesy of the Andre family.)

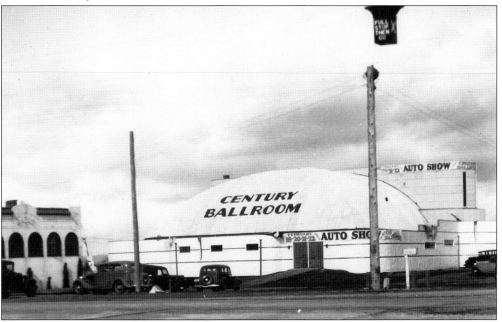

In 1934, Mac Manza and Jimmy Zarelli opened the doors to the large Century Ballroom dance hall. They would host car shows, walkathons, but most importantly the big bands—including Guy Lombardo, Louis Armstrong, Glenn Miller, Kay Kyser, Benny Goodman, and Lawrence Welk. Over 4,700 fans were in the ballroom to hear Tommy Dorsey's band in 1940. Just south of the ballroom is the 1939 version of the Poodle Dog. (Photograph by Ferd Reichlin Sr., courtesy of the Reichlin family.)

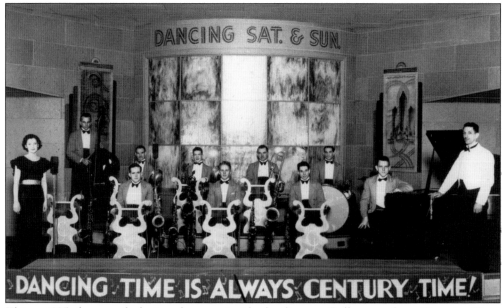

This c. 1935 photograph depicts the stage inside the Century Ballroom, where "Dancing Time Is Always Century Time!" Large dance halls were strategically placed outside the city limits, as regulations on activities in unincorporated areas were not as stringent. In 1931, two other ballrooms had been constructed—the Spanish Castle in Midway and the Evergreen Ballroom outside of the Olympia city limits. (Courtesy of the Tacoma Public Library, Richards Studio Collection, no. G25.1.008.)

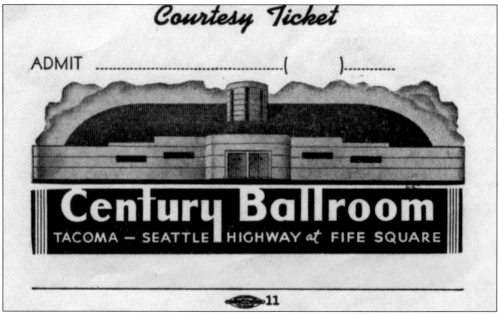

Pictured here is a courtesy ticket for the Century Ballroom acquired from Perry Reiter's stepdaughter. Perry was the manager at the ballroom and was very active in community activities. During the 1940s, this would have been the hottest ticket in town. (Courtesy of Etta Chambers.)

With the 1950s came the start of what evolved as rock 'n' roll. Interest in the big band sound waned, as did the attendance at the Century Ballroom, which closed its doors in the mid-1950s. The 20,000-square-foot ballroom was converted to house an IGA grocery store, a Fuji's variety store, and other small shops. (Courtesy of LaRae C. Herron.)

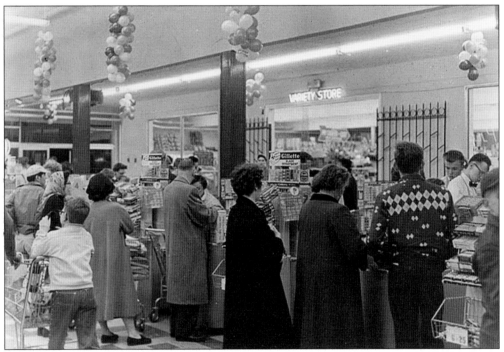

The Topper IGA Market, operated by the Herron family, opened in February 1955. Nine years later, it was destroyed by a devastating fire. For a short time, it offered a second, large grocery store in Fife. A new structure was built, but it never had the draw that the Topper IGA had in those nine short years. In this photograph, it is evident how one could access the Fuji's variety store from IGA. (Courtesy of LaRae C. Herron.)

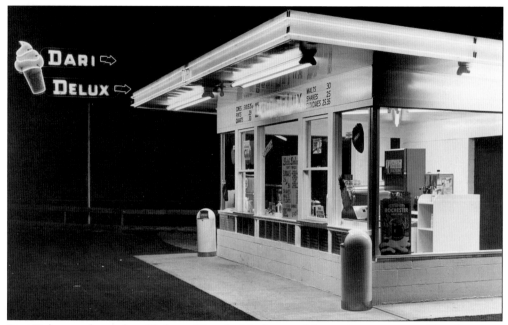

Dari Delux was located on Highway 99 and a block east of the main intersection. This fast-serve restaurant was built in 1951 and operated by the DeTray family of Fife for about 15 years. (Courtesy of Rosie DeTray.)

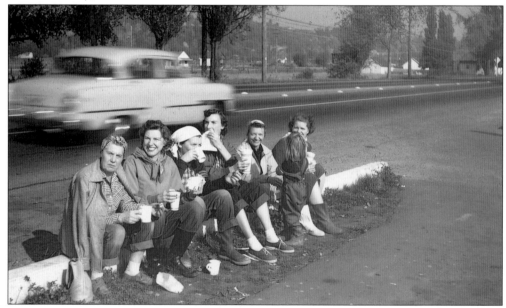

Some members of the Fife Garden Club are enjoying lunch from Dari Delux. From left to right are Margarete Emenegger, Marge Hammer, Gerry Wyman, Charlene Parker, Mary Errigo, young Vicky Errigo, and Mildred Holmdale. The highway is behind them, and Fife Heights is on the hillside. This photograph was taken by Olga Cronquist in 1955. After taking the picture, Olga returned to finish her burger but found that Margarete Emenegger was sitting on it. "Well," said Emenegger, who was from Switzerland and spoke with a distinguishable dialect, "I was just keeping it warm." (Courtesy of the Olga Cronquist family.)

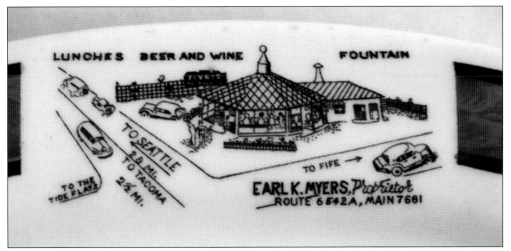

On the southeast corner of Pacific Highway and Fifty-fourth Avenue stood a hexagonal building known for years as the White Spot Tavern. Previously it had been operated by Earl K. Myers and known as Myers' Curb Service. Customers could drive up and place their orders for a sandwich. This photograph shows the edge of a plate that would have been used by indoor diners. (Courtesy of Kathleen Lathom.)

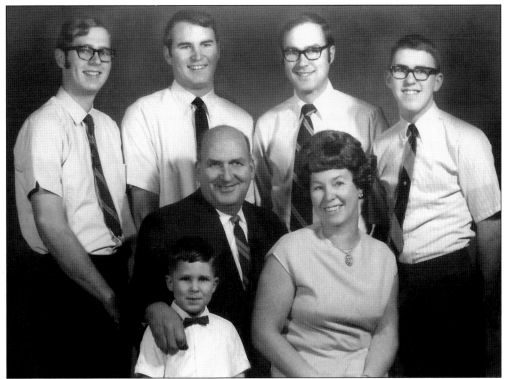

Every farming community appreciates having a veterinarian in the vicinity. Living and operating a clinic near the original Fife Square was Dr. Lloyd Gustafson. In this c. 1969 photograph, he is seated with his wife, Virginia, and their son David. Standing are, from left to right, sons Terry, Ron, Garard, and Richard. The family's second Fife home was removed and replaced by the current Fife City Hall. (Courtesy of the Gustafson family.)

The construction of motels just off the highway for the convenience of travelers as well as young families became a popular business venture. Many of the spaces at this particular motel were like small apartments with two or three bedrooms. This photograph was taken in 1951, when the motel was named for the Kelley family, who built it as a second source of income. It is now called the Glacier Motel. (Courtesy of the Tacoma Public Library, Richards Studio Collection, Series A58472-2 and the family of A. Dewey Kelley.)

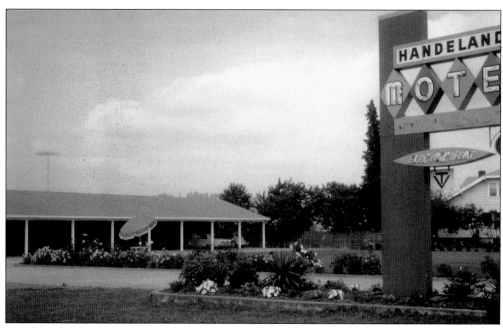

Handeland's Motel, shown about 1958, was constructed by Torvald Handeland and located to the north of the Pick Quick on Highway 99. Truckers on the highway will note that this structure is now called Bates Motel, a name one is likely to remember. (Courtesy of the Handeland family.)

Pictured here are teenagers Einar (left), Pauline (center), and Arne Handeland. In the background to the left is the sign/screen of the Fife Drive-In, in front of which is the small Pantley family store. To the right is the service station that was operated by Alex Hergert. In the background is the beautiful Mount Rainier, known to locals as "the mountain." (Courtesy of the Handeland family.)

Young Dennis Garre, son of Edward Garre, was at his grandparents' home when this photograph was taken around 1951. In the background is the KMO radio tower; the station's office building was located on Highway 99. On the right side, on land previously owned by Colonial Gardens, is the screen for the Fife Drive-In. (Courtesy of the Edward Garre family.)

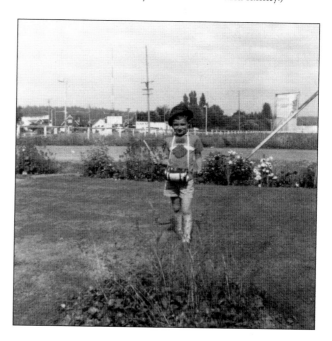

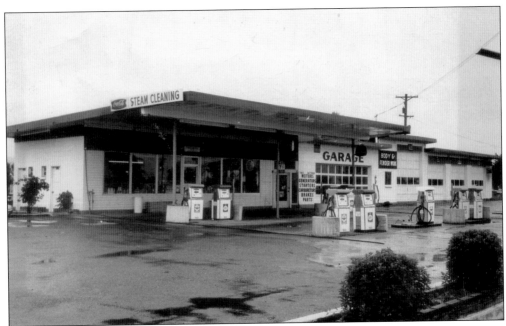

Alex Hergert operated this service station on Highway 99 and also ran a towing service. Immediately west of this facility was the Pick Quick. (Courtesy of Fife Service & Towing and the Waldner family.)

This photograph was taken from the home of Meinrad "Mike" and Anna Bisig looking in the direction of Mount Rainier. They lived near the intersection of Goldau Road and Highway 99. Visible are the used car lot and small building that preceded the Pick Quick's opening in 1949. (Courtesy of the Bisig family.)

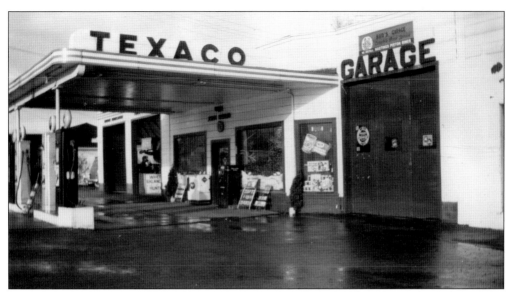

The Al Bunge family owned a Texaco service station (pictured here around 1955) that was managed by Jack Ensrude. Its location was on the north side of Highway 99 just before heading over the bridge to Tacoma; this bridge was paved before the highway between Seattle and Tacoma was completely surfaced in 1928. The mechanic on duty was Bud Claseman. (Courtesy of the Bunge family.)

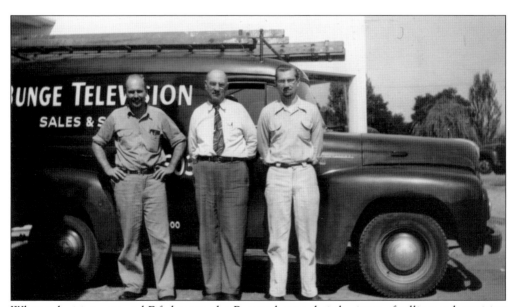

When televisions entered Fife homes, the Bunges began their business of selling and repairing television sets. Pictured here around 1954 are Robert (left), Al (center), and Harold Bunge with their first truck used for television repair. (Courtesy of the Bunge family.)

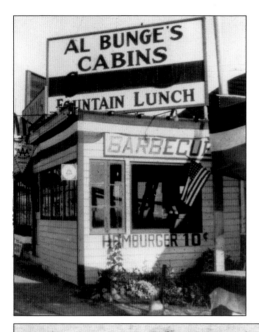

The Al Bunge family also operated the Shamrock Café, rented cabins, delivered heating oil, and raised blueberries. (Courtesy of the Bunge family.)

Both of Al and Mabel Bunge's sons, Robert and Harold, were involved with the family businesses. When not working, Mabel would use some of her spare time to compose poems reflecting her life's experiences. (Courtesy of the Bunge family.)

SPECIALS *from our Menu*

BREAKFAST

Ham or Bacon, with Toast and Coffee — 35c	Hot Cakes and Coffee	20c
	French Toast and Coffee	25c
Oat Meal and Cream — 20c		

LUNCH

Home Made Chili — 15c	Clam Chowder — 15c	
Oyster Stew — 20c	Dutch Lunch and Large Beer	30c
Shamrock DeLuxe Hamburger 10c	Individual Chicken Pie — 15c	

DINNER

Special T-Bone Steak — 40c	Old Fashioned Ham Steak — 40c	
Pork or Veal Chops — 40c	Fried Chicken — 50c	
Italian Spaghetti — 35c		

Dancing We Cater to Special Dinner Parties MAin 1810
[We Feature Alt Heidelberg on Draught]

ENTERING OR
LEAVING TACOMA

THE SHAMROCK

FOOT OF BRIDGE
SEATTLE-TACOMA HIWAY

Six

LIFE IN FIFE

If there was one thing that Fife residents would have in common during the time period of the 1890s into the 1960s, it would be that life in a small farming town was a positive experience. Many lived and/or worked on a farm. As a result, these individuals appreciated, maintained, and valued a strong work ethic. Many would assume responsibilities at a younger age than counterparts in the city may have. Youngsters would often have animals requiring ongoing care. There was plenty of space for play to be organized and undertaken by the children.

Having a community representing various ethnic backgrounds was an enriching experience. Cultural traditions and culinary specialties were enjoyed. An annual international dinner was held, and everyone looked forward to his or her favorite menu item. The author's favorite was Jennie Bevegni's "green spaghetti"—still a favorite today.

Families worked and played well collectively. In the early days, the barn dances drew young couples together, and later they would all support the annual firefighters' dance and Lions Club's fundraisers, such as the annual birthday/anniversary calendar.

Among students, strong relationships were established over time; most of them were in classes together from kindergarten to graduation. A number of the teachers were members of the community, and their children attended Fife schools. The teachers and the parents knew one another, and doing well in school was valued.

Fife was a small town where everybody knew each other's name—or at least the family to which a person belonged. This was also in a time period when people knew their neighbors and those who may have lived in the houses previously. Family members were involved in sports, music, church, local clubs, and/or community activities.

The proximity of Fife to Seattle and Tacoma made for easy access to major department stores, theaters, musical performances, museums, national parks, beaches, special events, and medical facilities. For many, it was the ideal place to live and grow.

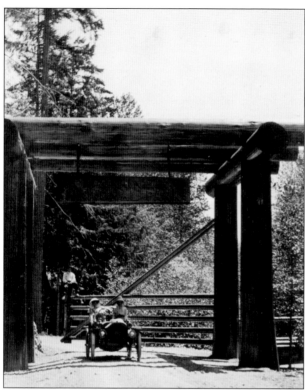

Trips to Mount Rainier were popular with Fife families. Here, a car carrying at least one member of the Albert family goes through the entrance gate into Mount Rainier National Park. (Courtesy of the Frank Albert family.)

Bocce was a favorite with the Colonial Gardens' workers, most of whom were of Italian descent. It was often played on Sunday afternoons. (Courtesy of the Andy Boitano family.)

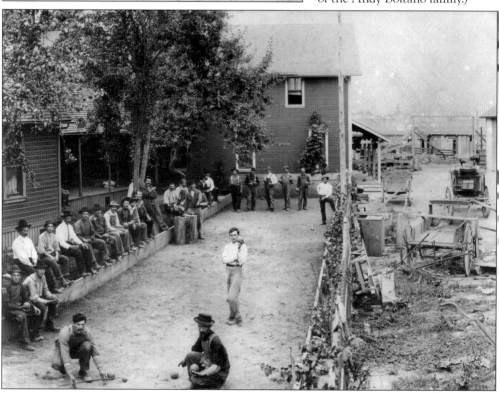

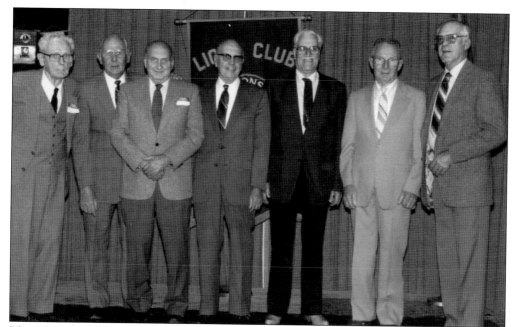

The Fife Lions Club's charter date was October 3, 1951. The charter members played a very active role in the community during their years of service. Posing in this photograph some years later, they are, from left to right, George Cronquist, Bob Sowders, Lloyd Gustafson, Harold Bunge, Henry Wollen, Bud Walsh, and Roy Herting. (Courtesy of the Fife Lions Club.)

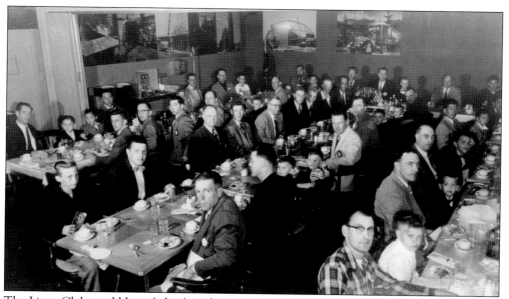

The Lions Club would host father/son dinners. This one is probably around 1952. (Courtesy of the Fife Lions Club.)

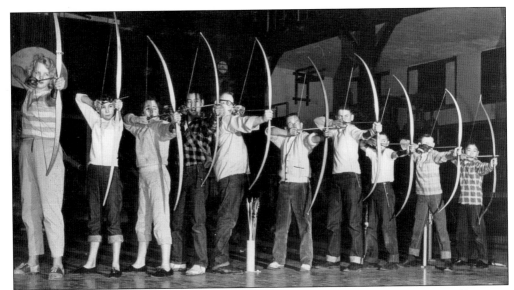

The Lions Club also provided instruction in archery, as demonstrated here around 1962. (Courtesy of the Fife Lions Club.)

The Lions continue to have an annual ham dinner. Vic "Pinky" Johnson (left) and Fred Bevegni are pictured at one such event in the 1960s. (Courtesy of the Fife Lions Club.)

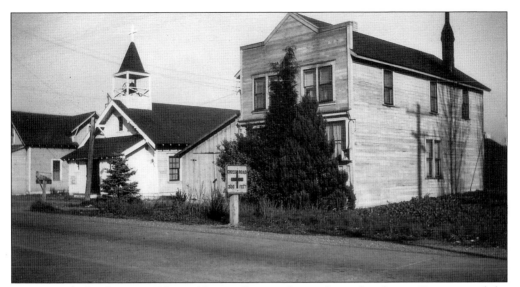

Roman Catholics living in Fife would typically attend one of two churches in Tacoma until the former Fife Japanese Language School was acquired in 1942 and converted for their use. The couple who had taught at the language school had lived upstairs in the building next door, and Father Quick resided there when the St. Martin of Tours Catholic Church acquired the property. (Courtesy of the Merritt family collection.)

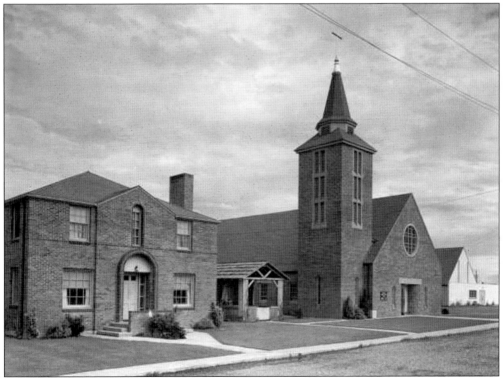

In the late 1940s, the main church building at St. Martin of Tours Catholic Church and the rectory were completed and have been in use since that time. (Courtesy of the Tacoma Public Library, Richards Studio Collection, A52082-9.)

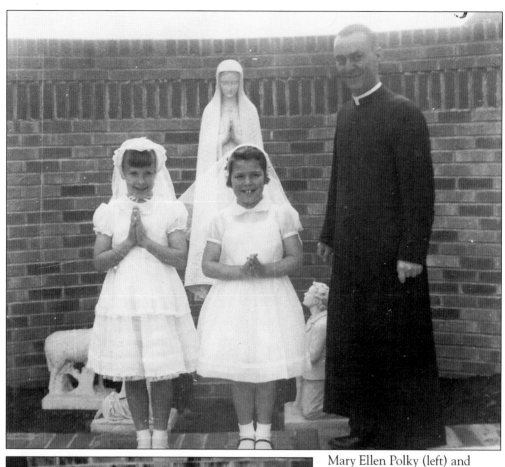

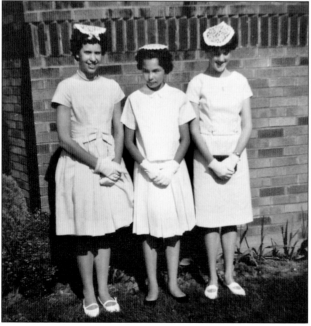

Mary Ellen Polky (left) and Cathy Boitano had their First Communion at St. Martin of Tours Catholic Church in June 1957. The priest at that time was Father Harrington, who followed Father Quick, the popular priest who was the first to serve the Fife community. (Courtesy of the Polky family.)

In 1963, Mary Ellen Polky (left), Jeanette Pasinetti (center), and Barbara Gaschk were confirmed at St. Martin of Tours Catholic Church. (Courtesy of the Polky family.)

In 1907, Henry Sicade donated land and helped to build the Fife Chapel, which was located on Fifty-fourth Avenue just south of the intersection with Highway 99. The chapel was designed to serve the needs of the community for all denominations. Previously, families would gather for home meetings. (Courtesy of Mission Woods Church.)

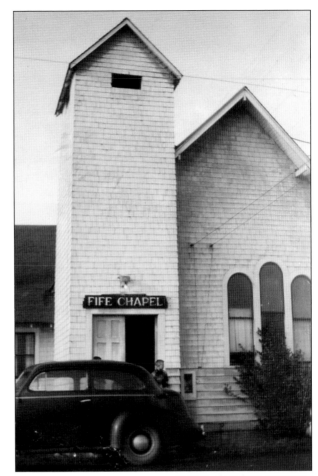

In 1950, Fife Presbyterian Church opened its doors on Twentieth Street, with Jerry Wilson as pastor. A number of dignitaries joined in the dedication festivities that December. (Courtesy of Mission Woods Church.)

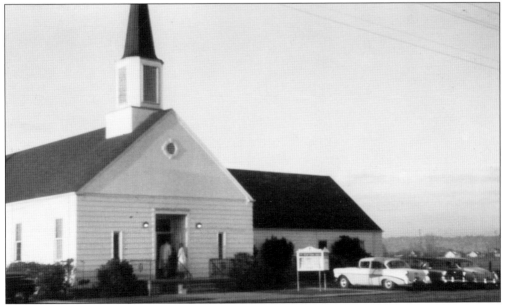

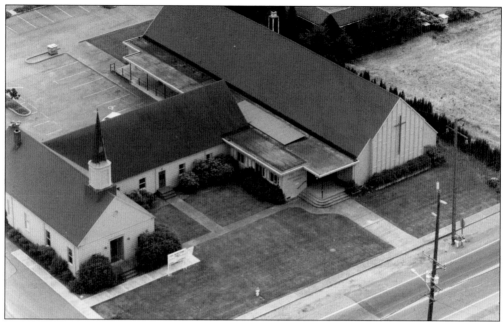

In 1960, Fife Presbyterian Church celebrated an expansion of its campus, which has since been sold. The members of this congregation now meet at the Mission Woods Church in Milton. (Courtesy of Mission Woods Church.)

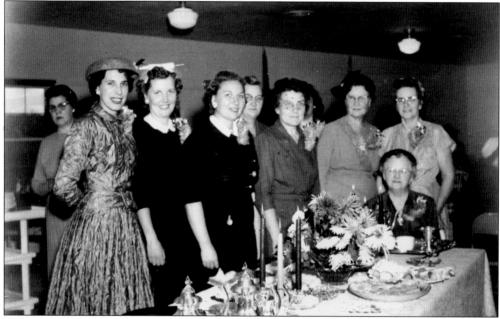

Gathered here in 1956 are the past presidents of the Fife Circle, all members of the Fife Presbyterian Church. The lady in the back is unidentified; the other women are, from left to right, Jeri Wyman, Mildred Merritt, Lois Rees, Sylvia Melius, Alma Vinson, Marion Meridian (hidden), Mabel Bunge, Sarah Garman Telling, and Nellie Hopkins (seated). Sarah Garman was one of the two first Fife graduates; she would have a long life of nearly 101 years. (Courtesy of Mission Woods Church.)

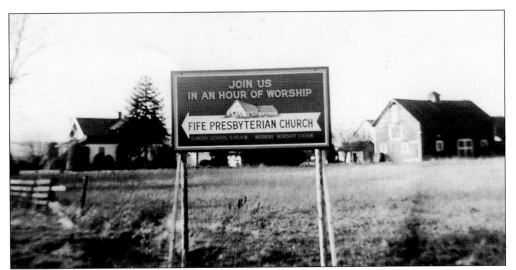

A sign would help folks locate the new Fife Presbyterian Church after it was completed in 1950. (Courtesy of the Rev. Gene H. Upton family.)

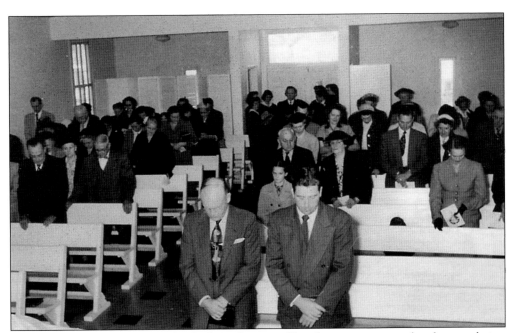

This photograph shows the inside of Fife Presbyterian Church two years or so after the completion of the new church in 1950. Gene H. Upton was the pastor at that time. (Courtesy of the Rev. Gene H. Upton family.)

This double wedding was for a set of twins, Mildred (left) and Marion Hanson (right). Mildred married Paul "Bud" Merritt, who was a respected builder, and Marion married Louis Dacca, a proficient farmer. The Dacca home is now the site of the Fife History Museum. Mildred and Marion were both proponents for preserving Fife's history. (Courtesy of the Andy Boitano family.)

In 1947, Dolores Smith (left) married Albert Bisig (second from left), the youngest son of Meinrad and Anna Bisig. To the right are maid of honor Bertha Koch Petorak and best man Mike Bisig, Al's oldest brother. The reception was held in the fourth floor ballroom of the Swiss Hall in Tacoma. (Courtesy of the Bisig family.)

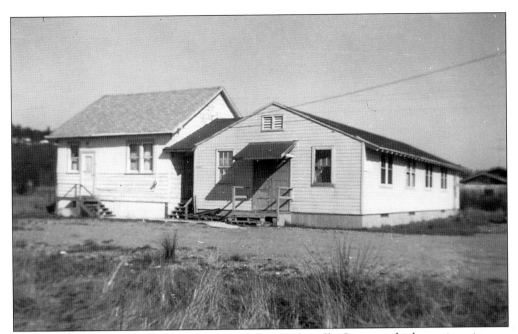

The first Grange to organize in the area was the Gardenville Grange, which was in existence between 1914 and 1919. The Fife Grange, pictured here, organized in 1937, with George Lawler selected as the first master. The Fife Grange obtained the original Fife chapel building and moved just the two-room addition to 5715 Fifteenth Street. (Courtesy of the Fife Grange, No. 1088.)

The Fife Grange was one of many Granges proudly presenting exhibits at the Puyallup Fair. (Courtesy of the Fife Grange, No. 1088.)

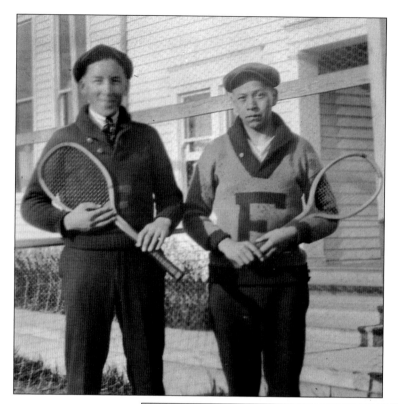

In 1922, Clarence Peterson (left) and Chuck Sicade were a couple of Fife's earliest tennis players. (Courtesy of Brian C. Payne.)

Kaz Nakamura, far right, is shown with a group of high school friends around 1947. Kaz went on to become a highly respected contractor and superintendent for Rushforth Construction in Fife, where two of his sons work today. (Courtesy of the Kaz Nakamura family.)

Norm Cronquist is on his way in his new 1957 Chevy Bel Air. (Courtesy of the Olga Cronquist family.)

Lee Johnson (wearing a Fife shirt) was the winner of a bike in a magazine subscription contest promoted by the Fife drugstore; Lee went on to graduate from Fife High School in 1965. Frank Dacca (in the jacket), to Lee's left, seems pretty happy with his prize that day as well. (Courtesy of Dorothy Canale Johnson Amrein.)

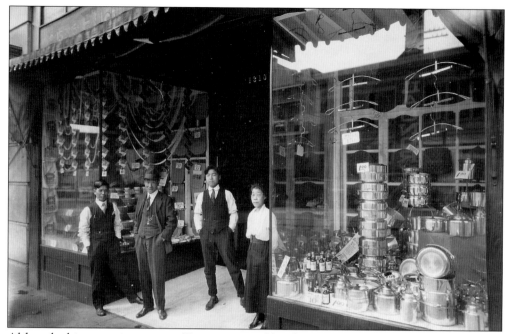

Although this emporium was in Tacoma, it would influence a future business in Fife—Fujis, which was a variety store adjacent to Topper's IGA from 1956 until 1964, when it was destroyed by a fire. The proprietor of this Tacoma store was a Fife resident, Hiroshi Kurimoto. (Courtesy of the Takashi Kurimoto family.)

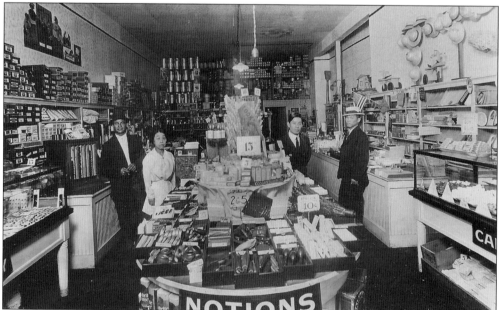

This shows the inside of the variety store in Tacoma owned by Hiroshi Kurimoto. The Kurimoto family did not return to Fife after World War II. The Horike family owned Fujis variety store when it was in Fife. When a 1964 fire destroyed the old Century Ballroom building where Fujis was located, the Horike family moved to Seattle and operated a variety store there. (Courtesy of the Takashi Kurimoto family.)

The last major flood of the Puyallup River affecting the Fife area took place in 1933; this was prior to the revision of the river's course. During this flood, some people used rowboats to reach the Century Ballroom or Poodle Dog restaurant. The river used to meander through the land near Levee Road, which is where the Olson and Carlson families farmed. Shown playing in the river in about 1914 are good friends and future farmers Fred Carlson (left) and Arvid Olson. (Courtesy of the Arvid and Leah Olson family.)

Pictured here are Floyd, Will, and Roy Andre, the sons of Ben and Clara Andre, who established the first Andre's market in 1905. This photograph is from about 1912. These horses were later drafted for service in France during World War I; they never returned. (Courtesy of the Andre family.)

This photograph shows David Bornander's birthday party around 1942, and the kids are playing a circle game in the yard. There are many girls in attendance. (Courtesy of the Ernest Bornander family.)

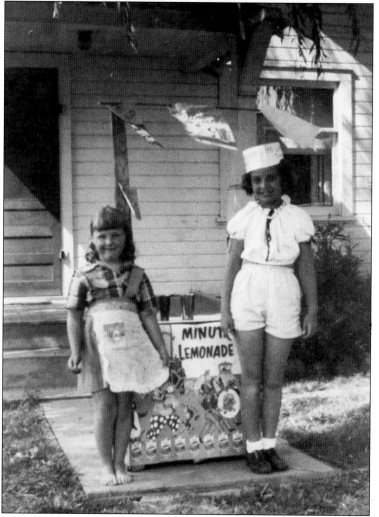

Pauline Cheslock (left) and Linda Kaelin pose with their attractive lemonade stand around 1951; it was at this time that they learned the importance of location, location, location. (Courtesy of the Cheslock family.)

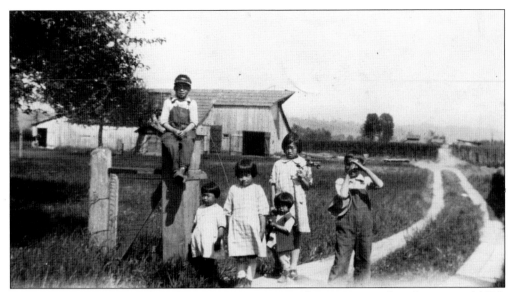

The Kawabata kids are ready and eager to greet guests at the entrance to their farm around 1928. From left to right are Yoshikazu, Isoye, Risako, Himeko, Kiyo (the eldest), and Kinjiro; Shiyogi had not yet arrived. (Courtesy of the Kawabata/Kawasaki family.)

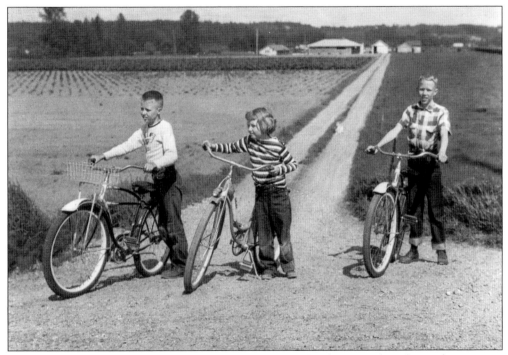

The Carlson kids—from left to right, Dean, Kathleen, and Joel—are gathered near the entrance to their farm around 1955. Fife was a great place to ride bikes. (Courtesy of Joel F. Carlson.)

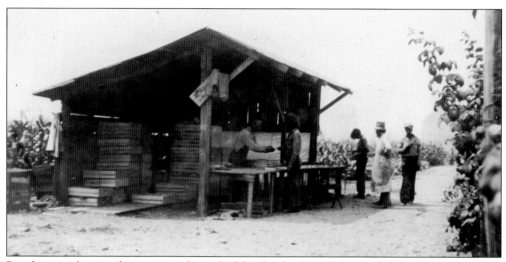

Raspberry pickers are lining up at the end of the day for their daily wages. There were a number of berry growers in Fife. (Courtesy of the Kawabata/Kawasaki family.)

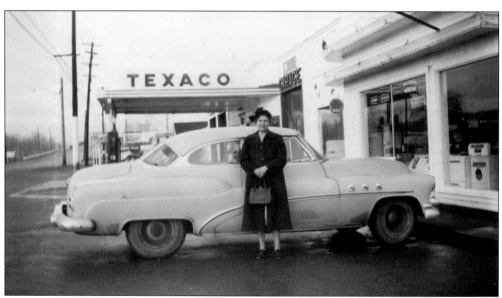

Mabel Bunge, shown here by the family's service station, was known throughout the area for her clever poems, such as this one regarding berry fieldworkers: "When hiring a picking crew / The farmer takes his chances / The little ones start berry fights / The bigger ones romances." (Courtesy of the Bunge family.)

Frank Dreyer and Bev Albert Walsh are riding their tricycles at their grandparents' home around 1928. A car sits in the garage. This home was on Frank Albert Road and not far from the train tracks. (Courtesy of the Frank Albert family.)

Cyril "Cy" Gius, pictured here around 1932, had a wide variety of interests and a few careers in his lifetime. His most interesting was when he went to law school after retiring from banking at the age of 55. He retired again at age 69, but he continued to serve as a faithful volunteer. Although he ended up in California, Gius had many fond memories of his Fife days. (Courtesy of the Gius family.)

Helen Peterson (left), Agnes Peterson (center), and Elsie ? appear to possibly be ready to take a ride on the interurban around 1916. There is a small building behind and to the left of Helen; such a structure was present at the interurban stops. (Courtesy of Brian C. Payne.)

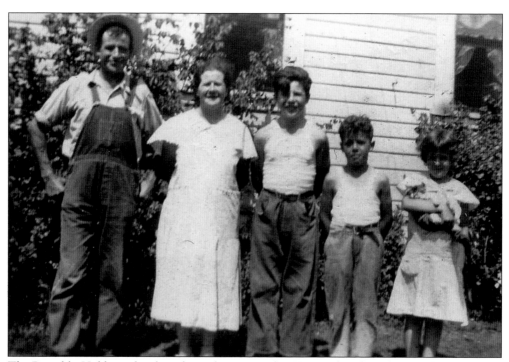

The Benedikt Holdener family is shown here around 1933 near their large home, which is still in place on the south side of Twentieth Street. From left to right are Benedikt, Lena (Burgi), Ben, Al, and Lee. (Courtesy of the Ben Holdener family.)

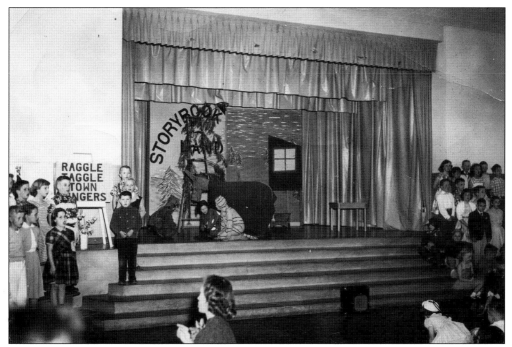

It appears "storybook land" may have been the theme for this c. 1956 school concert, which incorporated drama. (Courtesy of the Merritt family.)

The Hanson girls are standing in front of their home around 1932, preparing for a performance of "Columbia, the Gem of the Ocean." Thelma is the older girl, while the twins are Marion (left) and Mildred (who was always just a little taller than Marion). (Courtesy of the Merritt family.)

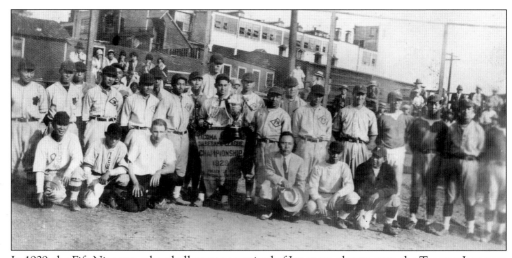

In 1929, the Fife Nippons, a baseball team comprised of Japanese players, won the Tacoma Japanese Baseball League Championship. They would return home with two trophies and a large pennant. Baseball was quite popular during this time period. (Courtesy of the Yoshioka family.)

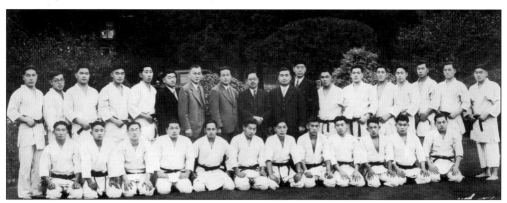

Judo was also important within the Japanese community, and Fife had a judo school along with a talented local teacher, Ryoichi Iwakiri. Pictured are the members of the 1936 team. This was the year that Masato Tamura, Jack Ohashi, and George Kawasaki made the Northwest all-star judo team. Masato Tamura became the Fife Dojo instructor in 1931. Fife frequently hosted judo tournaments. (Courtesy of the Kawasaki/Kawabata family.)

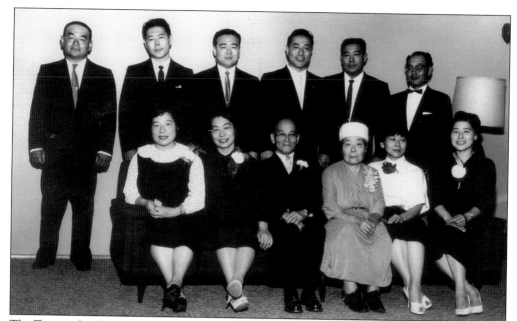

The Tamura family is gathered for the parents' golden wedding anniversary. They are, from left to right, (seated) Reiko, Tadako, Uichi, Tamako, Sachiko, and Fujiko; (standing) Hiroshi, Mitsuru, Tadasu, Masato, Yoshito "Vince," and Hikaru. One brother, Masaru, a fullback on Fife's 1939 state champions football team, was killed in Italy in 1945. In 1941, Masato moved to Chicago to work at the Jiu-Jitsu Institute of America; he became its owner in 1944. Vince joined Masato, became a three-time judo champion, and taught in Dallas. The other Tamura boys also were judo instructors. (Courtesy of Fujiko Tamura Gardner.)

These young Scouts were guided by Mrs. Rowe. Pictured around 1957 are, form left to right, (seated) Ann Rowe, Janice Osaka, Ginger Kawasaki, Ruth Christie, and Delores ?; (standing) Paulene Cox, Rose ?, Margaret Grimm, and Janice Zeigan. (Courtesy of the Kawasaki/ Kawabata family.)

From 1958 to 1960, Buck Owens (right) lived in Fife. He came to work at radio station KAYE and had his own television program on KTNT. During this period, he hosted Loretta Lynn (at microphone) on his show. A local businessman heard her on the radio, formed a new company, and recorded "I'm a Honky Tonk Girl," which rose to No. 14 on the country chart; her career then took off. (Courtesy of Buck Owens American Music Foundation.)

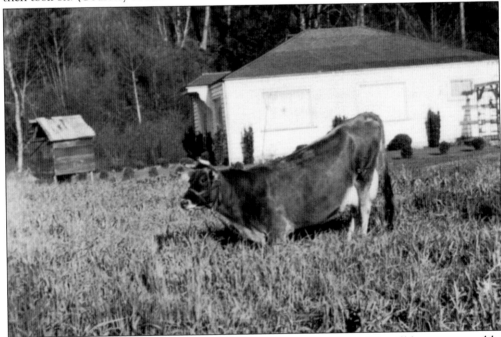

Although not everyone who has spent a portion of his or her life in Fife will have a career like Buck Owens, most would likely say that Fife was a good place to be and long for the farms of the past. No one could disagree that the Fife fields were beautiful—not even this sinking cow. (Courtesy of the Cheslock family.)

Seven

THE NAMING AND INCORPORATION OF FIFE

There is no official recording of the naming of Fife. A descendant of William H. Fife might tell you that it was named for the Fife family, who were early and influential settlers in the up-and-coming city of Tacoma. It appears that the name became a familiar tag for the community with the coming of the Tacoma-Seattle interurban.

Gustaf Peterson, who had come west on the Northern Pacific Railroad in 1883, purchased 10 acres on the reservation when it became possible to do so. In 1902, Peterson was approached by a representative of Stone Webster, the original owners of the interurban project, regarding the purchase of two acres for the interurban's tracks. Peterson grew primarily berries and cucumbers, and he was interested in having a stop near his home. The company would do so if he could come up with a name for the stop. The name Peterson suggested was *Fife*, in honor of William J. Fife, the son of William H. Fife. William J. went to the Philippines in 1898 as lieutenant colonel of the First Washington Regiment (or the Washington National Guard, as the unit is known today). Fife, an attorney, had initially been a first lieutenant for the newly formed Tacoma militia, which was established in 1881. He also helped in Seattle after the fire of 1889 as a member of the Tacoma Fire Company. Colonel Fife was apparently unaware that the name *Fife* had been given to one of the stops on the interurban route until he was a passenger one day. To his surprise, he heard his name being called.

School District No. 88 would eventually be designated Fife, as its location was close to this particular stop. Over time, the entire area became known as Fife, and the previous names for the neighborhoods faded away.

Often, the story of a town begins with its incorporation. In Fife, however, incorporation came too late to prepare for some of the changes that the mighty wheels of progress would bring. A later incorporation date also makes it more challenging to verify the early history of a community.

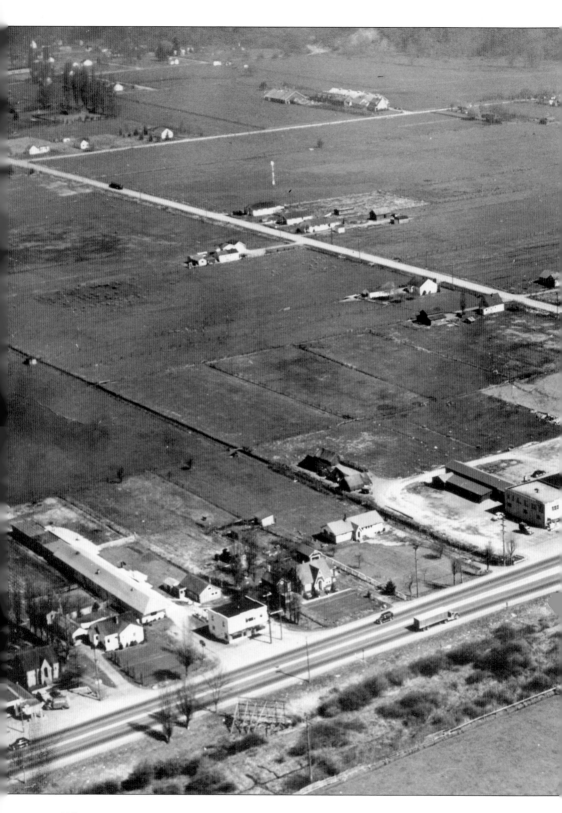

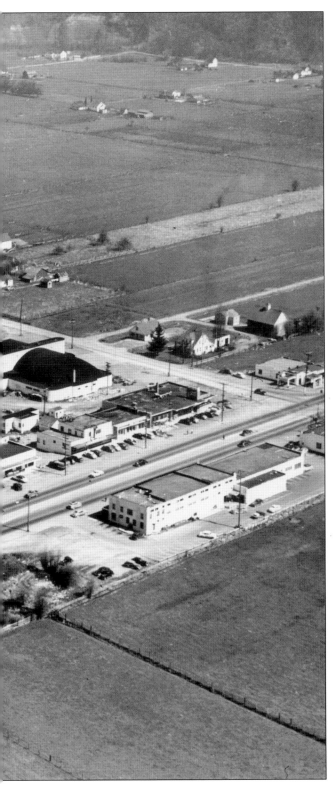

Rumblings of annexation by Tacoma were heard once again in 1956. Lifelong resident Joe Vraves became the chair of the Fife Incorporation Committee; discussions were held around the community and at PTA meetings. That summer, hearings were conducted at the Pierce County Courthouse. Some opposition came from within the community, as well as from Tacoma. However, in November, the incorporation vote was approved with a margin of seven votes. Fife became a fourth-class town in February 1957. When the vote was taken in the fall of 1956, most of the residents lived to the north of Highway 99. This aerial photograph provides yet another perspective of what Fife looked like over 60 years ago. The main roads in view are Highway 99 (near the bottom of the photograph), Fifty-fourth Avenue (upper left to lower right), Fifteenth Street (directly across from the Century Ballroom at middle right), and Blue Road (across the top of the image). (Courtesy of Lucy Cerqui.)

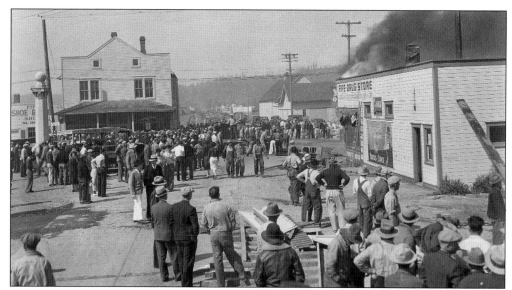

The worst fire to hit Fife was in 1935; it destroyed the drugstore and seven homes in old Fife Square. Fife did not have a fire department of any kind at the time. (Courtesy of the Tacoma Public Library, Richards Studio Collection, 2563-4.)

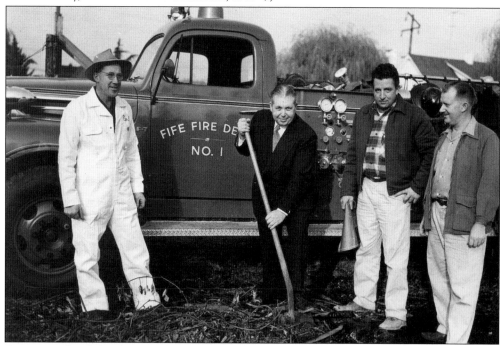

Citizens realized the damage that previous fires had inflicted upon the community, and they began organizing through the Fife PTA in the spring of 1948. By October, the Fife Volunteer Fire Department was officially established, and a fire station was built in 1955. This is the ground-breaking ceremony for the station, with, from left to right, Earl Rees, district fire commissioner; Lloyd Buchanan, Pierce County fire commissioner; Paul Merritt, contractor; and Victor "Pinky" Johnson, a volunteer firefighter. Fife would not have its own police department until shortly after becoming a town in 1957. (Courtesy of the Fife Historical Society.)

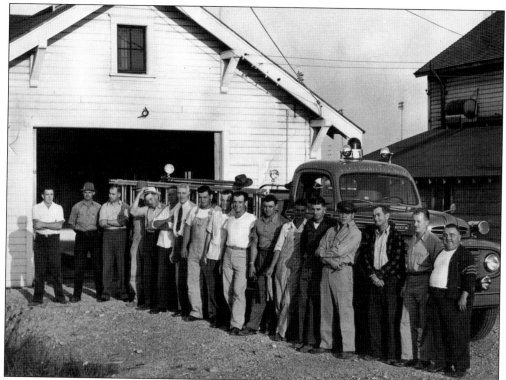

In order to establish a volunteer fire department, 25 volunteers were needed. The 17 pictured here are, from left to right, Paul Merritt, Pete Vogel, Bert Kepka, Bob Bevegni, Earl Rees, Bob Bulleri, Perry Reiter, Bob Bulleri, Charlie Babbitt, Guido Bini, Leo Parodi, Leo Bulleri, Joe Vraves, Frank Schnider, Dave Hulcey, Pinky Johnson, and Frank Laviola. (Courtesy of the Fife Historical Society.)

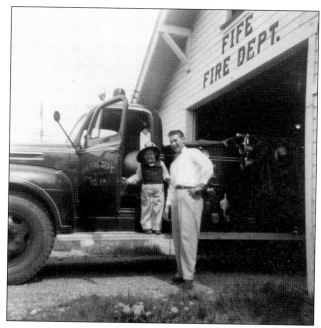

Young Mick Spane is with his uncle Carl Spane as he visits the station. Mick is able to try out the department's first truck. (Courtesy of Carl Spane and the Fife Historical Society.)

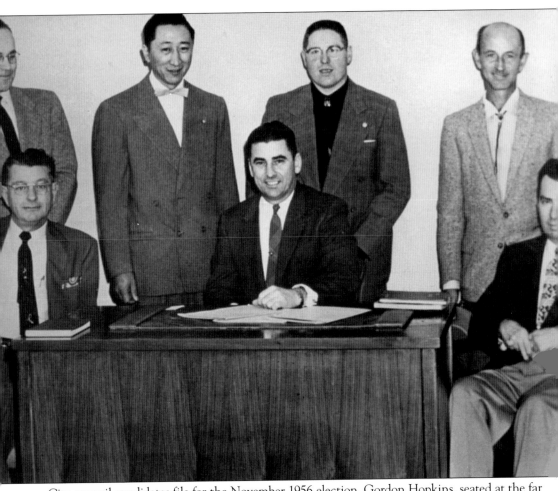

City council candidates file for the November 1956 election. Gordon Hopkins, seated at the far right, was later elected secretary-treasurer. Joe Vraves was selected as mayor; he is seated at the table. Seated at the far left is J.E. McElhiney. Standing behind, from left to right, are Charles Foisie, Robert Mizukami, Frank Schnider, and Louis Dacca. The incorporation resolution designating Fife as a fourth-class city with an estimated population of 950 people was filed with the secretary of state on February 11, 1957. The first meeting was called to order later that day. The council determined it would have its official meetings on the second and fourth Tuesdays of each month at 8:00 p.m. at the Poodle Dog restaurant. Vraves served as mayor from 1957 to 1980 and then went on to become one of the first elected Pierce County commissioners. Mizukami became Fife's second mayor and one of the first Japanese Americans to become an elected official in Washington State. (Courtesy of the Fife Historical Society.)

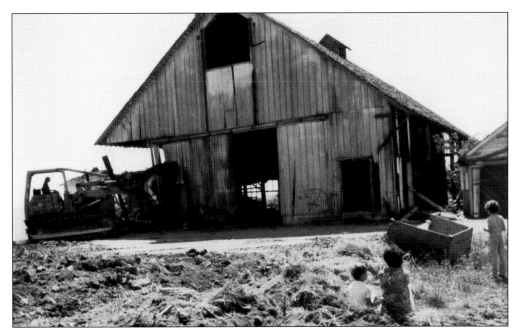

Ambuehl's Oakwood Dairy was one of a number of farms forced to relocate or cease farming altogether. These barns, in the process of being taken down in 1961, had been located on Ambuehl's 80-acre farm that was positioned at the northeast corner of the intersection of Fifty-fourth Avenue and Twentieth Street. The Ambuehl family was forced to relocate as a result of the development of Interstate 5. (Courtesy of the Valentine Ambuehl family.)

On March 25, 1973, there was an article about Fife in the *Tacoma News Tribune*. The reporter indicates, "But they'll never take the farm out of Fife." How wrong he was. Although annexation did not take place per se, eminent domain played a significant role in Fife and would forever change its character. Two major forces saw the removal of farms and homes—the expansion of the port and deepening of the harbor and the cutting of a wide, concrete layer through acres of virgin farmland for Interstate 5 (as represented by this earthmover). (Courtesy of the Polky family.)

Discover Thousands of Local History Books Featuring Millions of Vintage Images

Arcadia Publishing, the leading local history publisher in the United States, is committed to making history accessible and meaningful through publishing books that celebrate and preserve the heritage of America's people and places.

Find more books like this at
www.arcadiapublishing.com

Search for your hometown history, your old
stomping grounds, and even your favorite sports team.

Consistent with our mission to preserve history on a local level, this book was printed in South Carolina on American-made paper and manufactured entirely in the United States. Products carrying the accredited Forest Stewardship Council (FSC) label are printed on 100 percent FSC-certified paper.

MADE IN THE
USA